1914

GOODBYE
TO ALL THAT

Writers on the Conflict between Life and Art

Edited by Lavinia Greenlaw

PUSHKIN PRESS

LONDON

Pushkin Press
71–75 Shelton Street, London WC2H 9JQ

1914—Goodbye to All That: Writers on the Conflict Between Life and Art first published by Pushkin Press in 2014

Supported using public funding by

14·18-NOW
WW1 CENTENARY ART COMMISSIONS **LOTTERY FUNDED** LED BY IWM

Co-commissioned by 14-18 NOW, WW1 Centenary Art Commissions, supported by the National Lottery through Arts Council England and the Heritage Lottery Fund

With thanks to Andrew Franklin and Andrew Nurnberg

0 0 1

ISBN 978 1 782271 18 5

Set in 11 on 16.5 Monotype Baskerville
by Tetragon, London

Printed in Great Britain by CPI Group (UK) Ltd, Croydon, CR0 4YY

www.pushkinpress.com

CONTENTS

FOREWORD

ONE OF MY grandfathers was old enough to fight in the First World War. Bill was the son of a Scottish railway clerk and the first of his family to go to university. He was at Aberdeen, reading Classics when, along with three of his four brothers, he enlisted with the Gordon Highlanders. One was killed, one lost a leg, one was made deaf and Bill had his lower lip shot off. Can you imagine a narrower escape?

On his return, Bill endured pioneering plastic surgery which involved flesh from his chest being grown from a flap of skin into a pedicle, which was attached to his mouth in order to regenerate it. He was one of only two in his class to survive the war, and both decided to become doctors, Bill undergoing the last of his surgery during the first year of his training. He died of pneumonia when my father, his youngest child, was eighteen months old. My father became a doctor, too.

The First World War changed the course of life. It also changed the course of lives to come. A hundred years on, it is still in sight but has slipped out of reach. The gap opening up between present and past is full of reverberations,

something of which this collection of essays takes as its starting point. What does it mean to have your life and your identity as an artist shaped by conflict? I didn't want writers simply to return to the past but to formulate and reinvigorate questions we should never stop exploring. They were asked to consider the loss of literary innocence or ideals, the discovery of new ones, the question of artistic freedom, and what it means to embrace new imperatives or to negotiate imposed expectations.

While we all know this conflict as a "world" war, few of us are aware of the true extent of global involvement that political repercussions, complex allegiances and colonial grip incurred. The countries listed as participants range from China to Liberia, Alaska to Romania. In order to reflect something of this, I decided to ask ten writers from different countries involved in the War to contribute. Each has their own experience to bring to bear of the tensions—fruitful or not—between life and art, and how these are amplified by all kinds of conflict.

I have borrowed the title, *Goodbye to All That*, from Robert Graves's famously "bitter leave-taking of England", in which he writes not only of the First World War but of the questions it raises: how to live, how to live with each other, and how to write.

LAVINIA GREENLAW

GOOD VOICE

Ali Smith

ALI SMITH was born in Inverness in 1962 and now lives in Cambridge. She is the author of *Artful, There but for the, Free Love, Like, Hotel World, Other Stories and Other Stories, The Whole Story and Other Stories, The Accidental, Girl Meets Boy* and *The First Person and Other Stories*. Her retelling of Sophocles' *Antigone* is published by Pushkin Children's Books.

*T*HERE WAS A MAN *who had two sons. And the younger of them said to his father, Father, give me the share of property that is coming to me.*

Did you know about this? I say to my father. There was a German linguist who went round the prisoner-of-war camps in the First World War with a recording device, a big horn-like thing like on gramophones, making shellac recordings of all the British and Irish accents he could find.

Oh, the first war, my father says. Well, I wasn't born.

I know, I say. He interviewed hundreds of men, and what he'd do is, he'd ask them all to read a short passage from the Bible or say a couple of sentences or sing a song.

My father starts singing when he hears the word song. *Oh play to me Gypsy. That sweet serenade.*

He sings the first bit in a low voice then the next bit in a high voice. In both he's wildly out of tune.

Listen, I say. He made recordings that are incredibly important now, because so many of the accents the men speak in have completely disappeared. Sometimes an accent would be significantly different, across even as little as the

11

couple of miles between two places. And so many of those dialects have just gone. Died out.

Well girl that's life in't it? my father says.

He says it in his northern English accent still even though he himself is dead; I should make it clear here that my father's been dead for five years. We don't tend to talk much (not nearly as much as I do with my mother, who's been dead for nearly twenty-five years). I think this might be because my father, in his eighties when he went, left the world very cleanly, like a man who goes out one summer morning in just his shirtsleeves knowing he won't be needing a jacket that day.

I open my computer and get the page up where, if you click on the links, you can hear some of these recorded men. I play a couple of the Prodigal Son readings, the Aberdonian man and the man from somewhere in Yorkshire. The air round them cracks and hisses as loud as the dead men's voices, as if it's speaking too.

So I want to write this piece about the first war, I tell my father.

Silence.

And I want it to be about voice, not image, because everything's image these days and I have a feeling we're getting farther and farther away from human voices, and I was quite interested in maybe doing something about those recordings. But it looks like I can't find out much else about them unless I go to the British Library, I say.

Silence (because he thinks I'm being lazy, I can tell, and because he thinks what I'm about to do next is really lazy too).

I do it anyway. I type the words First World War into an online search and go to Images, to see what comes up at random.

Austrians_executing_Serbs_1917.JPG.
Description:
English: World War 1 execution squad.
Original caption: "Austria's Atrocities. Blindfolded and in a kneeling position, patriotic Jugo-Slavs in Serbia near the Austrian lines were arranged in a semicircle and ruthlessly shot at a command."
Photo by Underwood and Underwood. (War Dept.)
EXACT DATE SHOT UNKNOWN NARA FILE:
165-WW-179A-8 WAR & CONFLICT BOOK NO. 691
(Released to Public).

There's a row of uniformed men standing in a kind of choreographed curve, a bit like a curve of dancers in a Busby Berkeley. They're holding their rifles three feet, maybe less, away from another curved row of men facing them, kneeling, blindfolded, white things over their eyes, their arms bound behind their backs. The odd thing is, the men with the rifles are all standing between two railway tracks, which curve as well, and they stretch away out of the picture, men and rails, like it could be for miles.

It resembles the famous Goya picture. But it also looks modern, because of the tracks.

There's a white cloud of dust near the centre of the photo because some of these kneeling men are actually in the process of being shot as the photo's being taken (EXACT DATE SHOT). And then there are the pointed spikes hammered in the ground in front of every one of the kneeling prisoners. So that when you topple the spike will go through you too. In case you're not dead enough after the bullet.

Was never a one for musicals, me, my father says.

What? I say.

Never did like, ah, what's his name, either. Weaselly little man.

Astaire, I say.

Aye, him, he says.

You're completely wrong, I say. Fred Astaire was a superb dancer. (This is an argument we've had many times.) One of the best dancers of the twentieth century.

My father ignores me and starts singing about caravans and gypsies again. *I'll be your vagabond*, he sings. *Just for tonight.*

I look at the line of men with the rifles aimed. It's just another random image. I'm looking at it and I'm feeling nothing. If I look at it much longer something in my brain will close over and may never open again.

Anyway, you know all about it already. You don't need me. You did it years ago, my father says, at the high school.

Did what? I say.

First World War, he says.

So I did, I say. I'd forgotten.

Do you remember the nightmares you had? he says.

No, I say.

With the giant man made of mud in them, the man much bigger than the earth?

No, I say.

It's when you were anti-nuclear, he says. Remember? There was all the nuclear stuff leaking onto the beach in Caithness. Oh, you were very up in arms. And you were doing the war, same time.

I don't. I don't remember that at all.

What I remember is that we were taught history by a small, sharp man who was really clever, we knew he'd got a first at university, and he kept making a joke none of us understood, *Lloyd George knew my father* he kept saying, and we all laughed when he did, though we'd no idea why. That year was First World War, Irish Famine and Russian Revolution; next year was Irish Home Rule and Italian and German Unifications, and the books we studied were full of grainy photographs of piles of corpses whatever the subject.

One day a small girl came in and gave Mr MacDonald a slip of paper saying, Please, sir, she's wanted at the office, and he announced to the class the name of one of our classmates: Carolyn Stead. We all looked at each other and the whisper went round the class: Carolyn's dead! Carolyn's dead!

Ha ha! my father says.

We thought we were hilarious, with our books open
at pages like the one with the mustachioed men, black
as miners, sitting relaxing in their open-necked uniforms
round the cooking pot in the mud that glistened in huge
petrified sea waves over their heads. Mr MacDonald had
been telling us about how men would be having their soup
or stew and would dip the serving spoon in, and out would
come a horse hoof or a boot with a foot still in it.

We learnt about the arms race. We learnt about
Dreadnoughts.

Meanwhile, some German exchange students came,
from a girls' school in Augsburg.

Oh they were right nice girls, the German girls, my
father says.

I remember not liking my exchange student at all. She
had a coat made of rabbit hair that moulted over everything
it touched, and a habit of picking her nose. But I don't tell
him that. I tell him, instead, something I was too ashamed
to say to him or my mother out loud at the time, about
how one of the nights we were walking home from school
with our exchange partners a bunch of boys followed us
shouting the word Nazi and doing Hitler salutes. The
Augsburg girls were nonplussed. They were all in terrible
shock anyway, because the TV series called *Holocaust* had
aired in Germany for the first time just before they came.
I remember them trying to talk about it. All they could

do was open their mouths and their eyes wide and shake their heads.

My father'd been in that war, in the Navy. He never spoke about it either, though sometimes he still had nightmares. *Leave your father, he had a bad night,* our mother would say (she'd been in it too, joined the WAF in 1945 as soon as she was old enough). My brothers and sisters and I knew that his own father had been in the First World War, had been gassed, had survived, had come back ill and had died young, which was why our father had had to leave school at thirteen.

He was a nice man, poor man, he said once when I asked him about his father. *He wasn't well. His lungs were bad.* When he died himself, in 2009, my brother unearthed a lot of old photographs in his house. One is of thirty men all standing, sitting and lying on patchy grass round a set of First World War tents. Some are in dark uniform, the others are in thick white trousers and jackets and one man's got a Red Cross badge on both his arms. They're all arranged round a sign saying SHAVING AND CUTTING TENT, next to a man in a chair, his head tipped back and his chin covered in foam. There's a list of names on the back. The man on the grass third from the left must be my grandfather.

We'd never even seen a picture of him till then. One day, in the 1950s, after my parents had been married for several years, a stranger knocked at the door and my mother opened it and the stranger said my father's name and asked did he

live here and my mother said yes, and the stranger said, who are you, and my mother said, I'm his wife, who're you? and the stranger said, pleased to meet you, I'm his brother. My father said almost nothing when it came to the past. My mother the same. The past was past. After my mother died, and when the Second World War was on TV all the time in anniversary after anniversary (fifty years since the start, fifty years since the end, sixty years since the start, sixty years since the end), he began to tell us one or two things that had happened to him, like about the men who were parachuted in for the invasion of Sicily (my father was an electrician on one of the warships going towards Italy) but by mistake were dropped too far out from land so the sea was full of them, their heads in the water and the ships couldn't stop, you *couldn't just stop a warship, we waved to them, we called down to them, we told them we'd be back for them, but we knew we wouldn't and so did they.*

Now I tell my father, who's five years dead, you know, I wrote to the Imperial War Museum recently about that old picture with your dad in it, and I asked them whether the white clothes he's wearing meant anything special, a hospital worker or something, and a man wrote back and told me maybe your dad was an Army baker but that to know for sure we'd need Service records and that the problem with that is that sixty per cent of First World War Army records were burnt and lost in a German raid in 1940.

Things get lost all the time, girl, he says.

Do you know if he was a baker, maybe? I say.

Silence.

My grandfather doesn't look much like my father in the picture, but he looks very like one of my brothers. I've no idea what he saw in his war. God knows. There's no way of knowing. I'll never know what his voice sounded like. I suppose it must have sounded a bit like my father's. I suppose his voice was in my father's head much like my father's is in mine. I wonder if he could sing.

Red sails in the sunset, my father sings right now, out of tune (or maybe to his own tune). *Way out on the sea.*

Gas!—GAS!—quick, boys! That was the Wilfred Owen poem. In it, *gas* was written first in small letters then in capitals, which, when I was at school, I'd thought very clever, because of the way the realization that the gas was coming, or the shouts about it got louder the nearer it came.

Oh carry my loved one. Home safely to me.

And Owen had convalesced, and met his friend Siegfried Sassoon, and learnt to write a whole other kind of poetry from his early, rather purple sonnets, at Craiglockhart Hospital near Edinburgh, which was close to home, even though Edinburgh was itself a far country to me, at fifteen, in Inverness, when I first read Owen.

He sailed at the dawning. All day I've been blue.

My father's voice is incredibly loud, so loud that I'm finding it hard to think anything about anything. I try to concentrate. There was a thing I read recently, a tiny

19

paragraph in the *International New York Times*, about a rare kind of fungus found nowhere else in the UK, but discovered growing in the grounds of Craiglockhart and believed by experts to have been brought there from mainland Europe on the boots of the convalescing soldiers. Microscopic spores on those boots, and weeks, months, years later—the life.

But I can't even think about that because:

Red sails in the sunset. I'm trusting in you.

Okay.

I sing back, quite loud too, a song of my own choice.

War is stupid. And people are stupid.

Don't think much of your words, my father says. Or your tune. That's not a song. Who in God's name sang that?

Boy George, I say. Culture Club.

Boy George. God help us, my father says.

The 1984 version of Wilfred Owen, I say.

Hardly, he says. Boy George never saw a war. Christ. What a war would've done to him.

Wilfred Owen was gay too, you know, I say. I say it because I know it will annoy him. But he doesn't take the bait. Instead:

People aren't stupid. It's that song that's stupid, he says.

It's not a stupid song, I say.

You got that Wilfred Owen book as a school prize, he says.

Oh yes, so I did, I say.

You chose it yourself at Melvens, he says. First prize for German. 1978.

How do you even remember all this stuff? I say. And really. What does it matter what prize I ever got for anything?

You were good at German, he says. Should've kept on with your languages. Should've learnt them all while you had the chance, girl. You still could. I wish I'd had the chance. You listening to me?

No.

No, cause you never listen, he says. And you were learning Greek last year—

How do you even know that? You're supposed to be dead, I say.

—and gave it up, didn't you? he says. As soon as it got too difficult.

The past and the future were hard, I say.

Start it again, he says in my ear.

Can't afford it, I say.

Yes you can, he says. It's worth it. And you don't know the first thing about what it means not to be able to afford something.

I'm too old, I say.

Learn anything, any age, he says. Don't be stupid. Don't waste it.

While I'm trying to think of other songs I can sing so I don't have to listen to him (*Broken English*? Marianne Faithfull? *It's just an old war. It's not my reality*)—

Here, lass, he says. Culture Club!

What about them? I say.

That fungus! In that hospital, he says. Ha ha!

Oh—ha! I say.

And you could write your war thing, he says, couldn't you, about when you were the voice captain.

When I was the what? I say.

And you had to lay the wreath at the Memorial. With that boy who was the piper at your school. The voice captain for the boys. Lived out at Kiltarlity. His dad was the policeman.

Oh, *vice*-captain, I say.

Aye, well. Vice, voice. You got to be it and that's the whole point, he says. Isn't it? Write about that.

No, I say.

Well don't then, he says.

It was a bitter-cold Sunday, wet and misty, dismal, dreich, everything as dripping and grey as only Inverness in November can be; we stood at the Memorial by the river in our uniforms with the Provost and his wife and some people from the council and the British Legion, and we each stepped forward in turn below all the names carved on it to do this thing, the weight of which, the meaning and resonance of which I didn't really understand, though I'd thought I knew all about war and the wars, until I got home after it and my parents sat me down in the warm back room with a kindness that was quiet and serious, made me a mug of hot chocolate then sat with me in a silence, not companionable, more mindful than that, assiduous.

Damn. Look at that. I just wrote about it even though I was trying not to.

Silence,

silence,

silence.

Good.

It's a relief.

That image of the soldiers on the railway tracks is still on the screen of my computer.

I click off it and look up some pictures of Inverness War Memorial instead. Red sandstone, I'd forgotten how very red. I never knew before, either, that it was unveiled in winter 1922, in front of a crowd of 5,000. Imagine the riverbanks, the crowd. I'm pretty sure I never knew, either, till now, and it's a shock to, that one in every seven men from Inverness who fought in the First World War died, or that the Scottish Highlands had the highest casualty rate, per capita, of the whole of Europe.

Then from God knows where my father says:

And do you remember, girl, when we drove around all that Sunday for the project you were doing at university, and you needed to record people speaking for it, but no one would stop and speak to you?

Yes! I say. Ha ha!

It was for a linguistics class. I'd wanted to test out something I'd been told all through my growing-up, that the people in and around Inverness spoke the best English.

I'd made him ferry me round the town and all the villages between Ardersier and Beauly trying to stop random people and get them to speak sentences into a tape recorder so I could measure the pureness of their vowels. For a start it was a Sunday, so there was no one much out and about. *But you know why it's called the best English,* one of the three passers-by who did stop when I asked said into the microphone. *It's because of the Jacobite wars with the English, because in the late 1700s when they banned the Gaelic—which was all anybody spoke here—and they moved the troops into Fort George and Fort Augustus and the soldiers intermarried with all the local girls, then the English that got spoken was a Gaelic-inflected English.*

Inflected, my father says now as if he's turning the word over in his mouth.

War-inflected.

That's it. I have a clever idea.

I go to the shelf and take down my *Penguin Book of First World War Poetry.* Its spine is broken and pages 187–208 are falling out of it.

I take a blank page and a pencil.

I flick through the book and I make a list of everything I've happened to underline in it over the years.

Consciousness: in that rich earth: for the last time: a jolting lump: feet that trod him down: the eyeless dead: posturing giants: an officer came blundering: gasping and bawling: you make us shells: very real: silent: salient: nervous: snow-dazed: sun-dozed: became a lump of stench, a

clot of meat: blood-shod: gas shells dropping softly behind:
ecstasy of fumbling: you too: children: the holy glimmers of
goodbyes: waiting for dark: voices of boys rang saddening like
a hymn: a god in kilts: God through mud: I have perceived
much beauty: hell: hell: alleys cobbled with their brothers: the
philosophy: I'm blind: pennies on my eyes: piteous recogni-
tion: the pity war distilled: I try not to remember these things
now: people in whose voice real feeling rings: end of the
world: less chanced than you for life: oaths Godhead might
shrink at, but not the lice: many crowns of thorns: emptied
of God-ancestralled essences: the great sunk silences: roots
in the black blood: titan: power: in thirteen days I'll probably
be dead: memories that make only a single memory: I hear
you still: soldiers who sing these days.

I read it. A man of mud and sadness rises like a great
wave, like a great cloud much bigger than the earth, like an
animation from a Ministry of Information film, amateur,
jerky, terrifying, made of spores, bones, stone, feet still in
their boots, dead horses, steel. He speaks with all the gone
voices. He is a roaring silence. There are slices of railway
track sticking out of his thighs and wrists.

I'm in tears.

Christ.

The men in that picture were shooting people so close
to them that they could have reached forward and touched
them without even moving their feet, and the dust simply
rose in the air as the people got shot.

My father jogs my elbow.

Come on, girl, he says.

He sings the song as loud as he can in his Gracie Fields falsetto.

Sticking out my chest, hopin' for the best.

He waits for me to sing.

War is stupid, I sing again.

He nods.

Wish me luck as you wave me goodbye, he sings. *Cheerio, here I go, on my way.*

He waves. I wave.

Say it in broken English, I sing back.

GOODBYE TO
SOME OF THAT

Kamila Shamsie

I SHOULD START by saying I had the happiest of child-
hoods. This assertion is necessary, and I ask you to
continue to refer back to it, because it may otherwise get
lost amidst the dictators, house arrests, dead dogs and
watercress fantasies that follow.

My earliest narrative memory—by which I mean a
linked series of moments rather than a sensation or a single
image—takes place not in Karachi, the setting of almost all
my childhood, but in London. It's fairly unremarkable as
childhood memories go: lost on an unfamiliar street, aged
just under three. It was the middle of a summer holiday and
some babysitter, whom I remember not at all, had taken
four children between the ages of three and eight on an
outing, and couldn't find her way home. I remember the
feeling of panic, followed by relief when my father leant
out of a window across the street and waved at us. Years
later it occurred to me that the babysitter, whom I had long
thought of as singularly incompetent for getting lost mere
feet away from her destination, had been stymied—as I so
often am, now that I live in London—by a street on which

every building looks the same and buzzers yield no more information than "Flat 7" and "Flat 8" and "Flat 9". It's a disappointment to me, this memory, because it relegates to second place the memory which I would far prefer to claim as the first thing I remember when I think in terms of narrative.

While that first memory can be located only in "summer 1976", the date of this second memory exists in the history books, so I am able to pin it down to 7 March 1977. In the hallway of the house we lived in then, my father shows me the black stamp on his finger pad. There is sunlight coming through the long windows. He's been to vote, he explains to me, and although I don't yet know that I live in a country where this right has been rare, and will soon disappear again, I understand he's telling me something important. The stamp won't wash off for days, he says, so no one can vote more than once without their thumb giving them away. Then he says he's voted for my uncle, a politician in opposition to the incumbent party of Zulfikar Ali Bhutto. Do you think your uncle would make a good prime minister? he asks me. Although I don't say as much what I think is *how would I know? I'm three years old.*

A few months later my first long sequence of memories is formed, spanning days rather than minutes. With my parents and sister I travel to the north of Pakistan to visit my uncle in the hill town of Abbottabad. The elections have led to a military coup. Bhutto is in prison and my

uncle under house arrest. On the way to see him we stop in Murree, another pretty hill town where I see snow for the first time. One night while we are there, I turn on the TV to watch the highlight of my weekly viewing, *Little House on the Prairie*. But instead of Laura Ingalls Wilder there is General Mohammad Zia-ul-Haq, the President, who has imprisoned my uncle, addressing the nation at such length that the transmission of *Little House on the Prairie* is cancelled. It is from this moment that I become aware of despising the military dictator.

From Murree we travel to Abbottabad. (Many years later the English-speaking world will do everything possible to mangle the straightforward pronunciation of this town, named after an Englishman called Abbott, in order to make the place where Osama Bin Laden was killed sound as foreign as possible.) In the car my father explains that we have had to receive permission from the government to visit my uncle—and there, as we reach our destination, are two men in uniform who ask for our names, check them against a list, peer into the car and open the gate for us. It feels thrilling.

I have little sympathy for my uncle's predicament. He has a book-lined library, and a garden which seems as vast as a park to a four-year-old (the next time I visit, aged eleven, I'll be amazed at the ordinariness of its size). I wouldn't mind being under house arrest, I decide, if the house were this house. But the next day, or the day after, there's a picnic

in the hills surrounding Abbottabad. My aunt is in the car with my parents, my sister and me as the uniformed men open the gate and let us drive out. I turn around and see my uncle, waving goodbye to us from the driveway.

He doesn't know when he'll ever be able to get into a car and drive out again, I think. It is my first moment of empathy, my first attempt to imagine how it must feel to inhabit someone else's skin. In that, it is the moment of awakening for the novelist in me. And, relatedly, this particular narrative memory, with its span of time, its sub-plots, its character development, is the first of my life which I can think of as "novelistic".

Of course, all these firsts (and seconds) I recall have more to do with the myth I've created about my own life than with the truth of what I experienced between the ages of three and four. There must have been a thousand wounds and joys that seemed far more significant than elections and house arrests—and missing *Little House on the Prairie* would have been all about Laura Ingalls Wilder and not at all about General Mohammad Zia-ul-Haq. Even so, this is the narrative I've inhabited all my adult life: my own personal Origin Story.

It may come as no surprise, then, that my first novel, *In the City by the Sea*, told the story of a young boy whose uncle is under house arrest. The political strand of that novel started via a letter I was writing to a friend while at university, recalling that visit to Abbottabad: *Despite the fear and uncertainty that must have pervaded my uncle's house what I remember*

most clearly about that winter was the smell of pine cones. And then I wrote: *Hmmm… that sounds like the opening line of something.* For a long time a minor variation of that was the opening line of the novel, though eventually it became the first line of the second chapter. (I regret the use of "pervaded" now.) There was almost nothing directly autobiographical in the novel other than the smell of pine cones, but I did have a child watching a man under house arrest waving goodbye to a departing car—*and the look on Salman Mamoo's face was that of a man who watches a car drive through his gate and knows he may forever have to stand on the driveway and wave to it, goodbye.*

I was only twenty-one when I started to work on *In the City by the Sea* and it's impossible now for me to look back and separate the writing of the novel from the writing of my Origin Story. Which came first? Did the novel reveal truths about the events of childhood which had deeply ingrained themselves into my psyche, or did I construct a fictional version of my own childhood in the process of writing the novel? It doesn't particularly seem to matter. What mattered was how early in my writing life I came to link Pakistan and its politics to memory and narrative.

Except, twenty-one wasn't really so early in my writing life. I was nine when I first declared I would be a writer and eleven when my best friend and I embarked upon a co-authored novel about dog heaven titled *A Dog's Life, and After.* (I remain impressed by the comma, though I suspect that was the work of my best friend in whose handwriting

that title, with punctuation, appears on the first page of the school exercise book in which we wrote it.) We'd both had pet dogs who had died recently—the death of Topsy was a far more significant and traumatic event in my childhood than military coups or imprisoned uncles. When that was done, we wrote another novel about a time machine, in which our characters encountered Cleopatra and Julius Caesar. And then I branched out into a solo act with two fantasy novels which were set in green and pleasant lands which looked nothing like the world around me and came straight out of the Tolkien-inspired fantasy novels I was reading at the time.

I wrote the first fantasy novel before General Mohammad Zia-ul-Haq was killed in a plane crash in August 1988, and the second after the elections which brought the thirty-five-year-old Benazir Bhutto to power. Those days leading up to the elections were a time of dizzying optimism. Karachi transformed into a vast party, with its own danceable soundtrack in the form of all the catchy election songs for the different political parties. Benazir's party had the most catchy song of all. You wouldn't know any of this was happening by reading my fantasy novels, in which princes were born to rule and those who opposed them were on the side of Wrong.

The truth is I didn't know at the time how to bring the world around me and the world of the novel into conversation with each other. I grew up in Karachi, reading novels

in English, which were all set in faraway places that bore no resemblance to the world I was living in. Nothing stopped me from loving C.S. Lewis's *Narnia* books, in which the villains had dark complexions, curved scimitars and turbans. If those were the rules of this imagined world, so be it. Why should I have to consider my own nation, religion, complexion when reading? Surely the whole point of reading was that fiction had nothing to do with a person's lived experience? What was there anyway in the world around me that could possibly be as interesting as the picnics and watercress sandwiches that filled the days of Enid Blyton's characters? (The vast disappointment of discovering that "watercress" was merely some leafy green thing can hardly be expressed.)

But soon after the death of Zia-ul-Haq all this was to change. Was it merely a pleasant coincidence of timing that, just as one kind of openness was entering the political world, another kind was entering my reading life? This came via the writers on my mother's bookshelf, who became of great interest to me as I approached the age of sixteen: Salman Rushdie, Anita Desai, Gabriel García Márquez, Angela Carter. The novel, I came to understand through these writers, was a vaster place than I had ever imagined, and could accommodate stories of all the nations of the world and their complicated histories and social intricacies. I'd had a glimpse of this at twelve when I read *Anna Karenina* but at that time I wasn't yet ready to understand the lesson that Tolstoy's world—so strangely familiar to me

with its strictures and hypocrisies—was delivering. It would probably be accurate to say that at twelve I was simply too young to understand Tolstoy, let alone lessons about the novel form, but I want to make another claim about my inability, in childhood, to believe in new possibilities. At twelve, at fourteen, at fifteen I accepted the inevitability of the world as it was given to me. These were basic facts: Pakistan was a country under military rule; the English-language novel (which included Tolstoy as far as I was concerned) had no space in it for stories of Karachi. I was so convinced that nothing could change what I took for as one of life's certainties that even when Zia died and the adults started to talk about elections and Benazir Bhutto I wondered how they could be so foolish.

And then I was wrong, and it was exhilarating. How could that exhilaration keep from diffusing through my bloodstream and affecting everything? How could it not be responsible for the sense of wonder and possibility that I allowed to be awakened in me by Rushdie and Desai and Carter and García Márquez? Anything was possible in history! Anything was possible in the novel!

So it continued: this entwining of Pakistan's politics with my ideas of narrative and, therefore, the novel. Now it's entirely clear to me how completely this is an intellectual construction and, simultaneously, that it's one I've written and rewritten for so great a part of my life that I've made it the truth of who I am even if it wasn't that to begin with.

My writing was suspended a few months into Benazir's first term of office. There were O-levels to study for, novels to read, a social life to conduct, and then university to apply for. I tried to return to the fantasy genre, but ended up abandoning the book midway. I do, however, remember clearly the end I had in mind for that novel which was one of disillusionment: heroes were tarnished and victory had a bitter aftertaste. By this point Benazir's first government had been ousted from power after eighteen disappointing months in government, and the new Prime Minister was a former protégé of Zia-ul-Haq. The worlds of my fiction and politics were beginning to draw closer together.

It was at university in America a year or two later that I began to write fiction set in Karachi. It started as an act of homesickness, but quickly established itself as the only way of writing that made sense. It was the way in which it allowed me to burrow down deep into the world I knew to find the raw material for my fiction. For several years my life was spent between two vastly disparate worlds—seven months of term time on bucolic East Coast campuses and five months in the increasingly violent and divided world of Karachi. Writing was the bridge. Whether on one continent or the other, part of my brain continually inhabited an imagined Karachi. This imagined Karachi took particular root in graduate school where, still on the East Coast, I started to work on *In the City by the Sea*.

Over the next ten years, one book followed the other as military rule, the Partition of India and Pakistan, the 1971 Civil War and Karachi's present-day conflagration, the return of military rule, the legacy of the political activism of the '80s all found a way into my first four novels. My life continued to be nomadic, with London joining Karachi and the East Coast as a place where I would stop for a season before moving somewhere else. But it was always Karachi, and the history and politics of Pakistan, that I wrote about—and it was in Karachi that I did most of my writing. I came increasingly to think of the city as essential to my work. Wherever else I might travel to, and wherever else my plots might transit through as characters moved into and out of Karachi, there was no denying the source and seat of my writing.

I still think of it as accidental that, after four Karachi novels, I ended up writing *Burnt Shadows,* which has a Japanese woman as its central character and opens in Nagasaki in 1945. I had thought I was writing a novel set in Karachi during the summer of 1998 when first India, then Pakistan, tested their nuclear bombs—but somehow it got away from me entirely. Through writing what I had thought would be a very short prologue in a place and time I didn't know at all, I discovered the pleasure and deeply satisfying challenge of writing yourself from ignorance into familiarity rather than mining the stories you'd lived with your whole life. I didn't immediately realize that I was

severing the cord which had connected the most essential part of me—the writerly part—to the country of my birth and upbringing.

When the first draft of the novel was done, I realized I no longer had to be the nomad who always returned to Karachi to write. If I could write about Japan, I could write about anywhere—more specifically, I could write about places without spending a large part of the year there. And so I moved to London, the city which I loved but in which I had long believed I couldn't live because it would mean giving up the world from which my fiction derived.

Writing has felt terrifying ever since. In the Karachi years, as I now think of them, there were always these elements in place at the start of a novel: location (Karachi), time period (within my living memory), recurring theme (some aspect of Pakistan's history/politics which would tangle with the lives of my characters). Now that has fallen away. The tangle of history and the lives of individuals continues to recur, but now it can take place in the life of an Englishwoman in London and the Ottoman Empire at the start of the First World War, as in my most recent novel, *A God in Every Stone*. The familiar ground that was once the point of departure has gone. Now, at the moment of beginning, I stand on an unfamiliar street facing row upon row of possibilities, all undifferentiated from the outside, waiting for a hand to extend out of a window and call me home—panicked that it might not happen.

I don't know now how to return to that safer ground where early memories were formed and ideas of narrative first took root. I have written myself out of the Pakistan of my childhood and early adult life, and into this place of terror and panic—and previously unimagined possibilities.

A VISIT TO
THE MAGICIAN

Daniel Kehlmann

Translated by Carol Brown Janeway

W E MEET IN FRONT of the theatre. Both of us are nervous: I'm determined to make it onto the stage today. My friend Rafael, who was the one who organized the tickets, is seeing this magician for the fourth time; he's never been invited up onto the stage either, but this time is supposedly going to be different.

"Incredible," he keeps saying. "It's truly incredible. You'll see, the man's a genius."

Naturally we want to sit as close to the front as possible; the magician is supposed to notice us and single us out. To be sure of getting good seats, we get to the Admiralspalast a full twenty minutes before the show starts—but to our astonishment the place is already full. It holds 400 people; there are approximately 380 already inside. How can this be, how long have they been waiting? Feeling pissed off, we keep climbing the rows; we don't find two seats until we've reached the second-to-last. But maybe, says Rafael mournfully, it's actually good this way, sometimes the magician calls on people who are sitting right at the back, so it may turn out that we're in exactly the right spot.

The audience is laughing, giggling and chattering excitedly. The mood is oddly edgy; for most people, myself included, there is nothing less appealing than being dragged on stage in the middle of a performance. But when the show involves a hypnotist, that's the whole point of the exercise: you accept that you may be called on, and you'll make a fool of yourself. Maybe that's why I've always avoided such shows, and I said no to Rafael each of the three previous times, but now I've run out of excuses. I published a novel recently in which a magician plays a major supporting role; since it came out I keep being asked if I myself have ever been hypnotized, and I don't like having to keep smiling self-deprecatingly and shaking my head. I've reached the point where I want to know what it really feels like. I want to have something to talk about.

I leaf through the programme. Front and back are pictures of the magician wearing a serious, penetrating look, which is a given in his profession—hypnosis and laughter don't go well together. Every page contains another photo of him, always with the same serious expression, always with his right hand against his head, two fingers pointing upwards while the others are balled into a fist; it must be some classic hypnotist pose. I learn from the programme that intelligent and creative people are particularly susceptible to hypnosis. The most immune turn out to be the really stupid and the lame-brained.

The show starts. The stage lights dim theatrically, strange, oscillating music begins to spread throughout the theatre, and the magician enters. He is tall and imposing, he's wearing a knee-length black coat, and he's a lot plumper than in his photos. He talks about self-determination and freedom, sleeping and waking states; he says that we all shape our particular reality the way we want it to be, and this is what constitutes our freedom. He says several times that hypnosis is never more than self-hypnosis: "I don't do anything, you are the one who does everything." His voice reverberates, every word carries its own faint echo. And suddenly he's calling the first people up onto the stage. "Raise your hand if you want to join in." Rafael and I raise our hands, but we're too far at the back, he can't possibly see us, and indeed the only people he calls on to come up are from the first three rows. "Please come—you, you and you, and—yes, you!"

I'm relieved. It's not exactly consistent, but although I do absolutely want to be hypnotized, at the same time I absolutely don't. For, on top of everything else, I've just had the stupid thought that maybe he knows something about my book, maybe he'd recognize me and seize the opportunity to make a fool of me—presumably hypnotists do read books that feature hypnotists, don't they? I pull myself together and tell myself that I have no cause to be afraid of this portly, middle-aged man. I know that hypnosis is nothing out of the ordinary, and that in some European countries—Switzerland, for example, though not

Germany—you have to pass a practical exam in clinical hypnosis in order to receive your licence as a psychotherapist. It's perfectly normal!

But I notice that I don't really believe this. Hypnosis is astonishing. Hypnosis is magic. How can someone who has no magical powers make total strangers obey his commands?

The magician hands a book to three members of the audience, one after the other; each of them is to pick out a word silently, then he'll tell them what it is. Not hard, he says once he's done it; they've all made this or that movement, glanced in a particular direction or leant this way or that, thus giving things away, people are always communicating non-stop, and if you understand how to read the signals there are no deceptions and no secrets. The audience is impressed by what he's saying; they murmur and nod. Rafael is impressed, too, and when I whisper to him that this is a standard trick in the mentalist repertory and has nothing to do with body language, just with how the copy of the book has been prepared, he shakes his head and asks me to spare him my nonsense.

"The man's a genius," he says indignantly.

"Perhaps he is."

"That wasn't just some trick."

"It was, but it doesn't matter."

"He does it exactly the way he says."

As always when it comes to Rafael, I don't know if he's being serious or not. Rafael's day job, when he's not writing

witty books or producing records, is building and selling bookcases. These bookshelves are coveted by everyone in Berlin—even I have several. He makes a very good living from them, yet nobody can figure out whether he's serious about them or not. I have my suspicions that the whole thing is a practical joke that has taken on a life of its own. Rafael is well known, and actually typical in some way of contemporary Berlin, with its laid-back, ironic inhabitants. A lot of time has gone by since the Emperor ruled here. On the other hand, we're sitting here with a hypnotist, the place is full, and everyone is waiting to receive orders from the stage.

The magician does more tricks: members of the audience write keywords on notecards, he guesses what they are without having looked at the cards. Body language and psychological insight, he explains; for those who understand human beings there are no secrets. He seems to be relaxed and calm, and when he slips up and gives a woman a wrong date of birth he covers up the awkward moment smoothly, apparently unaffected. And yet: I saw this exact trick with the keywords and the notecard performed by another magician some months ago, but that time there was no psychologizing attached, and I liked it better.

But the audience is entranced. From time to time I can hear the clink of bottles tipping over on the floor; many people have brought their own beer, which is normal in Berlin—you take beer along to almost everything you do.

The magician is now visibly sweating; it must be really hot on stage. Whenever he calls on someone to come up, he stands a little too close and bends down towards them. It can't feel particularly pleasant; I wouldn't want him coming that close to me. But then suddenly he bows and walks off stage. It's the interval.

"Things will really start happening in the second half," says R. "That's when he begins hypnotizing people."

"We have to get up on the stage," I say.

"Absolutely!"

As we're waiting out in the lobby, I think about this strange place we're in. The Admiralspalast was once where Erik Jan Hanussen appeared—the first hypnotist to become famous all over Europe, who became a supporter of the Nazis despite the fact that he was Jewish, and shortly thereafter was murdered under circumstances that remain mysterious to this day. And 100 feet from here is the Friedrichstrasse station, which was once the border station on the suburban rail line between East and West; not 120 feet from here the Berlin Wall stood, and it's barely 500 yards to the Brandenburg Gate, and barely a couple of miles to Charlottenburg Palace, where 100 years ago an incompetent emperor dispatched his enthusiastic subjects to a war which everyone believed was going to be over almost before it had begun.

A bell rings to summon us back to our seats.

Twelve chairs have now been placed on the stage. The lights go down, some peculiar music of the spheres begins

to play and the magician enters. There's no such thing as hypnosis, he explains once again, only self-hypnosis. "Everything that happens comes from you! I do nothing. You do everything!" And, moreover, it only occurs when someone is in a trance state, not when they're asleep: they hear everything, they're aware of everything, and they *don't notice* that they're hypnotized. "So don't wonder about it. Don't ask yourselves if it's already happened. Don't turn it over in your minds. Just go along with it, go with the flow."

He's silent for a moment, as if he's pulling himself together. "So," he then orders, "clasp your hands in front of your faces with the index fingers extended."

We all obey. Every single one of the audience. My heart pounds—it's already really exciting.

"Look at your index fingers, breathe deeply, your index fingers are magnetized, they're being pulled towards one another, they're touching, your index fingers are touching!"

This always works, as I've known since my schooldays. It's a normal muscular reaction: if you clasp your hands with the index fingers outstretched, they will *always* start to touch after a time. I watch obediently as my fingers try to make contact with each other. It takes a few seconds and then they touch, just as he said.

"Now close your eyes," says the magician. "Breathe in, breathe out. Hands clasped tight. Breathe in, breathe out. They're clasped tight, really tight, you can't unclasp them, it's impossible! Open your eyes."

I open my eyes. The deep breathing has actually taken effect, I feel calmer, almost totally relaxed. I look at my hands. They are clasped tight, just as he said, which is natural because I did the clasping, and they're gripping each other because I'm doing the gripping, and then suddenly, while the magician is uttering the critical command: "Everyone who can't unclasp their hands—up on the stage!", I have the clear feeling that I could decide not to be able to open them. If I don't want to do it, it won't happen, precisely because it's my choice, and I wouldn't be not wanting to do so just because he told me I can't. And suddenly it's as if I'm not one person but two: I could give myself the order, and although it would be coming from me, it would still be his order. Then I would literally be unable to separate my hands. So then he would have been right.

The first members of the audience are already on their way to the stage, hands clenched; most of them have a strange, glazed expression on their faces, and even my hands are so tightly clasped that it almost hurts. I'm ready to get to my feet, but then I have a thought that shatters it all.

It's just not true, I think. These are my hands. I can unclasp them whenever I want. It's that simple.

I try it. And of course it's perfectly easy.

"Oh no!" Rafael exclaims in disappointment. His hands have parted too. I should have faked it, I immediately think, feeling guilty. I should have made my way down, if

only to see what would have happened. Perhaps no one's noticed. Perhaps I can still do it!...

But the moment has already passed; it's too late. There are about sixty people up on the stage, all of them with hands clasped, and the magician is going from one to the next, looking closely at their faces, tapping their hands, and he sends twelve of them to the prepared chairs. He is going to carry on with them; he thanks the others and sends them back into the audience.

And now he embarks with the twelve on the astonishing things we've been expecting. He instructs them to lean to the side with their eyes closed, and they do it and seem to fall into a deep sleep. He tells them to say their names, one by one, then he orders them to forget their names, and all but two of them actually say that they no longer know what they're called (two of them obstinately do pronounce their names, and the magician, totally unbothered, laughs the same way he laughed when he made the mistake about the woman's date of birth; he's really masterful). Then he tells them all to stand up: "Your feet are glued to the floor, you can't take a step. Try!"

They stand up. They try to propel themselves forwards by waving their arms, they twist this way and that, convincing everyone that it's true, they are incapable of walking even a single step.

I realize something. Something I've never found mentioned in a book or an article. It's hard to explain, almost

impossible indeed to put into words. The people he's picked out… well, how in the world can you say it without sounding condescending? Well, of the people on the stage, whom he's chosen to keep, none could exactly be described as charismatic. If contrariness and spiritedness had been the criteria, he'd have had to select twelve completely different ones; it's pretty clear that the opposite is the case and the ones who remain are visibly people who have no problem obeying orders.

And didn't he actually say this himself? "It all stems from you! You do it all, I do nothing." Can this be taken literally? Do we simply obey because we *want* to obey?

Once again I think of the irony that we're right here in Berlin in the Admiralspalast, taken up with a form of stage entertainment that reached its full flowering 100 years ago. And the magician had said in a recent TV interview that his greatest role model was Erik Jan Hanussen.

Now he wakes the twelve again: "Open your eyes, no more suggestibility, you feel fresh and clear-headed and awake, your subconscious is working for you, not against you; whatever you wish to do, you'll be able to do it. Stand up!"

They bow, laugh in embarrassment and want to return to their seats in the audience, but he tells three of them—a thin man with tattoos on his upper arms, a woman with a silver ring in her nose and a grandmother with white hair and a colourful sweater—to stay behind. "Stand still! Are

you awake? Of course you're awake. But you still can't move. Your feet are fixed to the floor."

And quite literally they can't take a step. They stand in a line and look at one another with a strange sort of pride. He has given his orders, they have obeyed them, and they like themselves in this role. He's stopped using suggestibility, they're no longer in a trance, what's been issued here is a straightforward order, point-blank, brutal. Why do they follow it?

They follow it because stage hypnosis really is no form of magic. There's no secret concealed in it, not even some spiritual mechanism that's been insufficiently researched; it's nothing more than the most normal effort to be like everyone else, to experience what everyone else experiences, to behave the way the authorities want you to behave. And then of course there's the desire not to do anything wrong in full sight of so many other people. There's nothing reprehensible in this. But suddenly I understand more of what makes dictatorships possible, and why people march off to war and even rejoice as they go.

Now he's sending the trio back into the audience, and he starts talking about freedom again. Anyone who can mould the world according to his own desires is free: he can see what he wants to see, hear what he wants to hear; his reality is the reality that suits him. Hypnosis thus teaches that you don't have to be a slave to reality.

"Thank you very much, and have a safe journey home!" He bows, there's clapping, it's still very hot.

"A genius!" says Rafael.

"Seeing what you want to see—that's freedom! Did he really say that?"

"Maybe we dreamt it."

On the way out we see the magician standing behind a table in the foyer; he's smiling and sweating and signing copies of his book without sitting down. The dust jacket has a picture of him looking serious, two fingers against his forehead. So why isn't he using a chair? It must be exhausting having to be continually dominant. There's a poster with a grinning troupe of cabaret artists who are going to go on stage tomorrow and take the piss out of the government, and the day after tomorrow it'll be the turn of a transvestite performing songs from the '20s.

We get out into the open air. It's warm; even this late in the evening, people are wandering along the Friedrichstrasse. I catch fragments of English and French. We're back in twenty-first-century Berlin, the multilingual city of Internet start-ups, graphic designers, advertising agencies and obligatorily hip haircuts. Looking around, you might think that the past is a very long way away.

We walk across the Weidendamm Bridge, past the cast-iron Prussian eagle.

"Pity!" says R.

"What about?"

"We didn't make it onto the stage."

"He's going to be back in two months."

Nobody was against it 100 years ago, I think to myself. The generals were for it, the aristocrats were for it and the journalists, the engineers, the painters, the street-sweepers, the waiters, the hairdressers and the doctors, the writers— particularly the writers—they all wanted war. There was no mass intoxication, no drug rush, no poisoning: it was all the most normal human quality of wanting to agree with everyone else.

"Good," I say. "Then we have to try again."

TEA AT
THE MUSEUM

Aleš Šteger

Translated by Urška Charney

ALEŠ ŠTEGER is a poet, essayist and novelist, writing in Slovenian. Aleš belongs to a generation of writers that started to publish right after the breakup of Yugoslavia. His first poetry collection *Šahovnice ur* (1995) sold out within three weeks of publication and heralded the arrival of a new wave of Slovenian artists and authors.

I DON'T RECALL how many years have passed since I last saw Z. Her telephone call takes me by surprise. How, I wonder, did she come by my phone number? Yet, as if she were regularly on the other end of my line, I immediately recognize her unusual, impulsive laugh, which is being interrupted by incoherent apologies. She has something urgent to share with me. We agree to meet in the History Museum café, not far from my work. It is April. The rain falls solid, night and day. But not on Monday morning, the day of our meeting, when the skies shine bright for the first time in two weeks. Z is punctual, down to the second. She has changed. We last met at a literary festival, many years back. She wears a rose-red tracksuit, at least twice her size, with a scarf embroidered with star-shaped glitter, and white tennis shoes. Now, her smile draws her face into deep creases. Her hands shiver. I would never have noticed had she not kept repeating that she couldn't stop shuddering, and that I must have thought her call, so out of the blue, to be strange, and how now she really feels crazy. But she just had to see me. We order tea. Z talks

about the weather, how rain never bothers her, rather the other way around, but that the sun is also fine. She keeps on examining the space in which we sit. The café walls are decorated with posters that feature military aircraft from the Second World War and the ancient people of the Roman city of Emona.

Unlike you, I don't favour rain. Water everywhere, too much of it. The last two weeks have been completely draining, I say. Thank goodness the sun has come out. You brought it, I tell Z.

Z says nothing in response to my compliment. Instead, she continues to eye the space around us. What an odd place, she says. I never sat in this café before.

I often come here. It is peaceful, in particular when it rains. Now and then I stumble upon a pensioner, a class of primary-school students who storm in only to vanish soon after. It is beyond time and space, this place. An island of peace and solitude. The museum itself seems to attract little attention. Even though its permanent collection isn't at all bad. They also mount temporary shows every now and then, but that wing is closed these days. They are putting on a new exhibition, though. You know, it's the centenary of the First World War and everyone is raving about it, I respond to Z, while she pulls down the zipper of her oversized tracksuit, the red of her wool jumper spilling out from beneath it.

Interesting, she says, and thanks the waiter for our tea.

You think so? I reply. I don't find it interesting at all. It is far too predictable. No different from other big anniversaries. But I must not complain. The museum invited me to write something for their exhibition catalogue.

What about? asks Z, and pushes the sugar packets aside.

I would have to write something about the First World War.

So? She sounds bored to death already.

I'm in a dilemma, I say. I have acquired a shelf-load of books on that period in history, yet the more I read, the more I realize how alien the First World War feels to me: a fabrication, a monument, an archive, I continue, before she is able to say anything. None of us played our part in it, and we no longer know anyone who did. The truth is that all the exhibitions and monuments do is mask the events they are intended to commemorate. At least, that's what Robert Musil thinks, with whom I can only agree. All these commemorations, exhibitions and films are nothing but rituals, pre-programmed rituals. We know, to the very last detail, what is to come, and we believe that such pomp can defend us against oblivion. But the war is long past us! We put it behind us long ago. In all honesty, is it not exactly oblivion that is the true saviour, the one we long for, even in spite of our rhetoric? Just take the Second World War, for example. Seventy years later we can hardly wait for the remaining witnesses to die off. What for? So that Hollywood, corporations and politicians can at long last

appropriate the stories of those who were there as their own. Also, much that happened during the Second World War is still visible, palpable, there to haunt us.

I take a sip of my tea. Z, her mind semi-absent, stares at the reflected light playing across the floor. The silence is painful, so I further unravel my thoughts.

You recover from the ghosts of the past only once the final witness has gone. Once the historical textbooks, documentary films, along with the statistics, are all that remain. And the First World War has evolved to be pure statistics. According to the standard principle of gradation: a lie, a bigger lie, statistics. Apropos of statistics: do you know that the nation that suffered the greatest loss during the First World War was Serbia? Interesting, isn't it? Especially if you take into account the role they played in the '90s during the Yugoslav wars. Serbians are the record holders of the First World War. Not in the absolute number who fell, but in casualty rate per capita. They lost as much as sixteen per cent of their entire population. Can you imagine? The numbers concerning Germany, England or France are, compared to Serbia, insignificant. Only about three per cent of their entire populations, I say, realizing that I was speaking too loudly, which had the waiter await my words from behind his counter. Needless to say, I go on, every soul lost in the war is one soul too many, every fallen soldier is the defeat of civilization. Just imagine, sixteen per cent of the entire population. That is colossal!

Z looks at me with her doubtful deep-blue eyes, and slurps her tea.

I think you may need something brighter. This jumper doesn't suit you, this navy blue encases you, she says. I know quite a bit about colours, you know? I've been healing people with colour therapy for years. You need yellow, perhaps something in orange, says Z, and takes another sip of her herbal tea.

I thank you for your colourful advice. Do you offer such guidance to your husband, as well? Does he no longer work in black and white, I reply, surprised at being lightly offended and sardonic in my response to her.

I help my husband, my son and many others, Z says quietly. People seek me out. The ability to think in colours is one we all carry within. I attract those who need me, for reasons unknown to me. Sometimes they invite me into their apartments. I walk in and I see the space, I see the people who live there and I ruminate over ways to heal them all. Just yesterday I visited a pair of architects. Their home used to be all white, pure minimalism. I suggested they paint the kitchen wall warm, with a tinge of orange. They were about to fall apart when they first saw me, but now… says Z and smiles.

Your husband, is he planning to exhibit any time soon, I ask?

This coming autumn. I find his exhibitions quite stressful, though. He is a marvellous photographer, but from the

development of the photographs onward I do just about everything for him—the exhibition concept, the selection, says Z. I curate the exhibition, prepare the invitations, I oversee the promotion, everything. He is simply not designed for this line of work. I do everything and then I vanish. You will never see me at an opening event. I hate crowds, talks, forced kindness. And all that small talk, it would drive me crazy!

Think of it as a part of your work, I say to Z, and take a sip of my tea.

A part of my work?

A part of your work, yes, I say. You know, today nothing happens without publicity, especially in the arts. All the things we do for money...

Some go to war for money, Z grumbles, her gaze fixing on a poster of a shot soldier at rest in an idyllic meadow, all in bloom.

Those were different times. Vast numbers of volunteers went to the Front during the First World War for honour. The war was a once-in-a-lifetime opportunity for them to achieve fame, to become heroes and to participate in something never to be forgotten. Nobody expected the Front to be a slaughterhouse. A final destination for the trains that arrived crammed with the boys who sang patriotic songs with great enthusiasm, and left crammed with only corpses and the wounded. No songs were sung there. That's unthinkable today. Everyone backs out at the first mention of the war, I say.

Z studies my face and shifts, restless, lightly about the chair. You think? she asks after a long, silent pause.

Well, perhaps not everyone, I say back and silently brood over my vacillation. What has made me feel this insecure? Something about Z irritates me, not her oversized rose-red tracksuit, not her red jumper, not her imperturbable mind. It is her quiet superiority. What could that be founded on? Anyway, she makes me feel inescapably as if I must defend myself or even apologize somehow, which bothers me a great deal.

We all were adults when Yugoslavia fell apart, I continue. Had all that really come on at full blast, I would have been drafted. My parents pondered ways to get me out of the country, which I wanted to hear nothing about. I must have been brainwashed by too many films about the Partisans and Germans, which I had seen in my childhood. But if I were in such a situation now, my advice would be to pack and leave. No war is worthy of my head. I shall never be the poet behind the front line.

But here I pray that none whom once I loved
Is dying tonight or lying still awake
Solitary, listening to the rain,
Either in pain or thus in sympathy
Helpless among the living and the dead,

Z recited quietly under her breath.

65

Who's the author? I ask.

Edward Thomas. I thought you knew him, Z replies, rather astonished.

I don't, I say, mildly upset. Yes, literature alone is a true testament of war. Forget about newspaper reports and official documents. Even letters to soldiers, penned by their wives, can be questionable. The closest we can get to what truly happened may be in literature and photography, perhaps some films. Historical essays almost always serve one ideology or another. They project nothing but the most current views, they project only what we are and how we perceive the world today onto a long-gone and radically different time.

Different how? asks Z, slipping off her white tennis shoes and tucking her bare feet beneath her.

That's exactly the point! Reconstruction would be viable if we understood how different we are, compared to our ancestors. History strives to do just that, yet it fails, time and again. Only through literature can we realize how impossible it is to have any true insight into the past, any true experience of it, and what's more we will become part of some other equally incomprehensible past.

Z stares at me. Thinking she needs to say something, I fall silent. But she continues to stare until, eventually, she whispers vacantly, I see your aura, it has a hole, here. She reaches across the table and lightly touches my jumper. Here, your heart chakra is pierced, you're leaking energy.

Perhaps I was shot by God, or by a woman, I laugh, and take another sip of my now cool tea. Or perhaps an old shell blew up while I was eating pasta, like in Hemingway? You read it, didn't you, *A Farewell to Arms?*

More than that, says Z, and gently begins to massage one of her feet.

That is what makes history in my view: cold pasta at the Front, not battle reports, not data on war casualties and the wounded, on military transport, weaponry and other logistics. What does such data tell you? Nothing! It just generates the clichéd images: mud, howitzers, wounded soldiers, cripples and the victims of gas attacks, field hospitals, women crying over the loss of their loved ones. We put these together however we choose and no one will object, because no one's left who could counter our version.

I don't know what historians would have to say about this, remarks Z.

You mean the market in academic history? The perpetuation of the ideology of the victorious? As if it were not enough to win on a battlefield, but the war of interpretation has to be won too! All that is nothing but an industry for the creation of past times! I have got so worked up that the waiter, now leafing through a newspaper at the bar, glances in my direction.

After a brief silence I add, more quietly, I have no past.

What do you mean, you have no past? Z smiles and extends her bare feet before me. Each and every one of us has infinite pasts!

67

As research for my piece for the museum catalogue, I consulted three experts on the history of Yugoslavia from the First World War to its disintegration. They each gave me a list of five, one of them even a list of seven, relevant books. Every book they recommended was written in English and they all were published in America or the UK. Their authors were all educated at either British or American universities. Don't you find that slightly odd? If our history is penned by Americans or the British, then for whom is this history written? We don't even know, we can't, or are not allowed to write our own, at least not the sort that would mean something more broadly. Our grandfathers fought on the Fronts, at Soča, Flanders, Turkey, and while they may be of mild interest to some local historical institute or museum, such as this one, what they did could easily mean nothing, even fifty kilometres outside of Ljubljana.

Z grins, as if I were endlessly entertaining. She uncurls her toes and lightly circles her feet, alternating directions. Then suddenly, as if struck by something, her face becomes serious and once again she tucks her feet beneath her.

Have you ever experienced regression? she asks, looking straight into my eyes. You know, into past lives? That is what I wanted to talk to you about. It must seem very strange. We hadn't seen each other in a long time and then I show up with a question like this. My God, this is making me tremble. What must you think? I didn't know what else to do. I am here to ask your forgiveness.

I look at Z and pour more cold tea into my cup.

Why an apology? You never hurt me, I say.

Haven't you ever felt as if you had been here before, as if all that is happening to you now happened before?

Well, I say, we have all heard of déjà vu. I know of people who believe they were Cleopatra or Jeanne d'Arc or the head of a concentration camp in a past life. But, joking aside, I've always been, hmm, not fearful, but wary of such unveilings.

Have you experienced perfection? What about God? A moment when all colours crystallize into light? Sometimes I dream of light so bright that I wake up in tears of happiness, grateful for all I can experience and see. I see you, I see your navy-blue jumper. You are closed in, you know. Probably you will never in your lifetime get to see what I see every month, sometimes every week. And perhaps that's good for you. It's all good just the way it is, says Z, and slowly begins to pull her while tennis shoes back on her feet. Everything is good for something.

I did see a bio-energy healer once. I had some problems and he came highly recommended, and I was curious. And then something unexpected happened. The healer circled his hands around my head for a while before finally admitting defeat. He had failed only twice before to see into his clients' past. I was the third such case. Presumably I walk the world with an impermeable barrier within, I laugh.

And that is why you think you have no past?

I don't know. I feel as if I'm guarded. As if there is a thick wall between me and any previous lives.

The amount of tea drunk slowly reminds me that I must soon use the restroom, but at this point I am not willing to interrupt our conversation.

Let's say that I go through regression and discover that I was Archduke Franz Ferdinand or Hitler, or that, as a soldier, I gassed others during the First World War. So what? How is anyone to benefit from this idiocy? I don't mean to offend, but such insights, even if they were true, are of little use. They can only fog our perception of ourselves. I am convinced that many gurus get wealthy from instilling such fog in us. Come to think of it, this is much like reading history books. I read a story and think that I have learnt something new about myself, when in fact I am merely confused and subject to manipulation.

But you were there. I know that you participated in the First World War, Z says, and readjusts her star-glittering scarf, which falls from her shoulder to sweep the floor.

Of course, I look at her and say, I am always there, when I read poetry from those days. I have certainly entered the past, if you mean in this manner. But the rest is only projection or wish fulfilment.

Z continues to stare at me.

No one touches poetry these days, in particular old war poetry, even though it is often surprisingly interesting. When abroad I used to be asked often what it meant to be

a responsible writer in time of war. What a question! Do these people have the slightest idea what it means to write in time of war? And who cares? Please! Consider the scope of things that poets took up during the Yugoslav wars. They held weapons, were in command, they were murderers, they defended or they rescued. There was nothing they didn't do. War is a stupidity, a horrendous simplification of thought. Sure, it must have been difficult to write poems.

Once again I shift in my seat, and ask myself why, in the name of God, I feel a sour taste in my mouth each time Z looks at me.

War poetry, once war draws to an end, is relegated to those who rummage through the past for whatever reason and to the classroom, where it's supposed to serve as a deterrent. Much of this material is devoid of literary value, I say, and shift about my seat once more. There are honourable exceptions though, I admit. My bladder feels ever tighter, and I know that I won't last much longer.

Z smiles. Still, had these poems not been written, we would have no history. Didn't you say just a minute ago that you only believe in the testament of literature?

I do, but I alone am irrelevant. The market wants something else. People want a ritual to be performed, a void to be filled: brass bands, wreaths, an opening ceremony of an exhibition held at a war centenary, this is what most people want, not poems. A spectacle is what placates them. The real past would only disturb them.

71

Are you feeling better? Z asks silkily, and rises.

I wasn't upset, I answer, wiping sweat from my forehead.

Still, I would like to apologize once more and ask your forgiveness, says Z and draws near, almost brushing against my armchair.

I stand up.

When I arrived, did you see anything?

What do you mean?

I mean, did anything cross your mind when you laid eyes on me?

It might have, I say.

What was it, asks Z?

I don't know, but for a moment I thought I'd dreamt of this place, and of something that happened here. Then again, I come here often. No wonder it creeps into my dreams.

What else do you dream about?

Most of the time I don't remember, I say, and shift from one foot to the other. The pressure has slowly built up to become unbearable.

You truly can't remember?

Well, perhaps I do remember something. Lots of water. I often dream of water.

Water?

A river, cold and crystal-blue... a waterfall, I mutter, and manage a smile.

I know the river, says Z.

You do?

I do. It is the Soča River. I saw everything, while in the state of regression, and I will never find peace unless you forgive me.

Forgive what, I ask, anxious?

I murdered you, she says. It was in Solkan. We were engaged when the First World War broke out. You loved me dearly, and I took advantage of your love. I betrayed your trust. And today I ask your forgiveness for all that I brought upon you.

Z, I honestly don't know what… I feel my flesh creep.

Water in your dreams is the water that swallowed your life. And I am responsible for it.

Z, it's not a problem, I forgive you everything, even though I don't know what… I try to force a smile.

In that moment Z embraces me. I feel her shuddering body pressed against mine.

I am sorry, I will be right back, I slip from the grip of her arms. Wait for me, so you can tell me how a femme fatale costs a young fellow his life, a life lost in the depths of the Soča River, lost not through a grenade but sadness.

Z dives deep into my eyes. Thank you, thank you! You know, you really should dress in brighter colours, she says, and takes a step away from me. Here, in your heart, here is your hole. You must do something about it. As if performing a healing manoeuvre, eyes shut, she reaches out a hand and holds it just above my heart. Moments later she

exhales heavily, opens her eyes and says, You really don't remember? I was the soldier, and you were my fiancée.

The memory of a recent dream hits me. I'm falling, a river beneath me, a soiled, lacy skirt that flutters about my hands as my body sinks infinitely slowly, towards a glacial river surface.

Uncomfortable, I hurry past the waiter, who continues to read his newspaper.

Z is gone when I come back. Her star-scattered scarf is draped over the chair where she sat. A little tea, hers the colour of amber and mine perfectly black, remains in our cups. I put on my coat and pay. The world outside is again grey with the rain, but I barely notice it. I am caught up in a rather absurd thought I don't know how to decipher: even if I were to meet Z again, I will never see her again.

IN SEARCH
OF UNTOLD STORIES

Elif Shafak

ELIF SHAFAK was born in Strasbourg, France, in 1971. She is an award-winning novelist and the most widely read female writer in Turkey. Critics have called her "one of the most distinctive voices in contemporary Turkish and world literature". Her books have been translated into more than 40 languages and she has been awarded the honorary distinction of Chevalier of the Order of Arts and Letters by the French Ministry of Culture.

S OME CHILDREN grow up listening to the tales of the past; others grow up listening to the silences of the past, though this they might not be aware of until years later. East and West, there are so many houses in which the family memory is handed down from one generation to the next, like a precious dowry from grandmothers to granddaughters. In other houses, however, it is silence that looms over the shadows of the past.

In the land where I come from silences are telling, weighty. There is more discontinuity than continuity, more amnesia than memory. As you saunter along the serpentine streets of Istanbul you won't come across signs that will inform you about who lived in that beautiful mansion by the Bosphorus once upon a time, or what happened to the residents of an old *konak*,[1] or the students of a military school, or the attendants of a church or synagogue now in ruins. Berlin and London are peppered with signs of urban memory: "George Orwell drank here!" claims a notice on a pub door. Characters from novels by Charles Dickens greet you on another wall in a busy street. Signs

of remembrance, no matter how sad or tragic, adorn the streets of Berlin. Not so in Istanbul.

In the 1900s an educated Turk would speak and read Ottoman Turkish, which was written with the Arabic script but retained a Turkish syntax with Persian elements. After the establishment of the modern Turkish nation state in 1923 a wholesale cultural transformation was initiated. Since the alphabet was changed in 1925 from Arabic to Latin, today the average Turkish citizen cannot read anything that dates from before that year: the text on an Ottoman grave, the inscription on a dry fountain or a poem carved in marble... Every day millions of Istanbulites walk by the remnants of the past without seeing, without knowing. Somehow we have become a society that cannot read the tombstones of its ancestors. There is too much forgetting in Istanbul and very little remembering. It's odd that a city so ancient now has the memory of an infant.

Only a flimsy, selective memory survives in the collective consciousness in Turkey. In order to learn more about history one ought to dig deeper into not only written culture but oral culture—songs, lullabies, recipes, tales. In the local customs and folklore reside traces of history.

The national and nationalistic official history taught at schools dictates what we are to remember, what to leave behind. And we, millions of us, obediently comply. Forgetting is way too easy in Turkey. Things are written on water, except the works of bygone architects and artists,

which are written in stone, canvas or paper, and somehow can outlive the era they were born in.

"What do you remember of the First World War?" I once asked my maternal great-grandmother. I was a student in high school and she was in her late eighties or early nineties, no one knew for sure, least of all herself.

I called her *Cicianne*, "Cute Mama". She seemed impossibly old with her high cheekbones and grey-blue eyes clouded with cataracts. At the dinner table I would close my eyes and listen to the rhythmic cracking sound her jaw made as she chewed her food. At times she would get suddenly edgy and start accusing everyone of putting various kinds of poison in her dish. I was both mesmerized by and slightly ashamed of her. She lived in our midst like a relic from another country, a figure from a novel none of us had had the chance to read.

"You want to know about war?" she asked back.

"Well, yes," I said, now unsure.

A frown set heavily between her eyebrows. Clearly she didn't like the question. Her answers were evasive and incomplete. Strange, I thought, for a woman who loved talking about her life and harked back to "the good old days" at every opportunity.

Still, she told me bits and pieces, hearsay and anecdotes, too many names of places and people, conveying the experiences of strangers as though they were her own and her family's undertakings as though they had happened to someone else. She mentioned women who had sold their

golden bangles, and larders that offered nothing to eat. She described soldiers frozen to death, hundreds of them in trench after trench, still standing, like trees of ice. Were such things real or made up? If real, were they events she had heard about from someone else, or had she witnessed them herself? I did not explore such questions.

"Horses," she said, "take longer to freeze than humans; it's their blood that keeps them warm. Did you know?"

I knew nothing about horse blood.

Soon after the day we had this conversation I finished high school, went away to college and did not see much of my great-grandmother. That same year she passed away. I greatly regret that I can never now learn the details of her life. Why hadn't it occurred to me to sit beside her for longer and just listen? What had I been thinking?

I was upset at myself for not asking the right questions at the right time, for being too infatuated with books and ideals and love affairs that seemed extra-important back then and left so little behind them. But mostly it was my desire to change the world that kept me busy in those years. I was so immersed in the wider picture that I did not see the story right there in front of my eyes, waiting to be told.

"Has the past said its farewells and left us for good or does it continue to exist within this moment, Cicianne?"

Where silences loom heavily over a family or a country, we writers fill in the gaps with our stories.

*

If wars were songs, the First World War would have been one long ballad, swirling in the wind, stretching high and low, reaching deep into our souls. The lyrics would effortlessly flow from one language to another: a verse in English, followed by one in German, the next in French... There would be words in Russian, Italian and Ottoman Turkish. And words that would be present through their absence, there but not there, like the ghosts of fallen soldiers.

The First World War changed everything, though it could not bring the peace so desperately needed. Still to this day it lives on in our collective memory more deeply and hauntingly than any other conflict. Challenging though this might be, we cannot help but ask: what would the world be like today had the First World War never happened? Would the "Second World War" have taken place, for instance? Would there still have been the Holocaust? A Cold War? Would things have turned out so differently that none of the tragedies of the twentieth century would have occurred?

Similar questions loom as to what might have ensued had the Germans won the war instead of losing it. What exactly the conflict achieved, and at what cost, are matters that are still debated, now that we are commemorating 1914's centenary, more than ever before. Whichever way we look at them, the narratives of the First World War seem to offer more questions than answers. Perhaps that's why we can't help going back to it, time and again, with more questions ready to hand.

Given the enormous bulk of literature that focuses on this dark episode, one might assume there is not much left to say about it. Nevertheless its social, cultural, philosophical, literary and artistic repercussions have still not been fully understood. Those repercussions reach far and wide. After all, it was too quick to be waged, loaded with rival jingoistic interpretations, and to this day too slow to be unravelled.

"The sick man of Europe…" That is what the Ottoman Empire was called by European politicians and diplomats in the days preceding the war. I find two things noteworthy in this description. First, that the phrase wasn't "the sick man of the Orient" or "the sick man of the Middle East", but of Europe. The Ottomans were regarded as part of old Europe, albeit perched precariously, as if about to fall off Europe's edge at any moment.

Secondly, there is the matter of gender. In caricature after caricature published and circulated at the time the Ottoman Empire is depicted as a thin, etiolated, at times hunchbacked male wearing a fez or a turban, in either case the headwear accentuated to demonstrate his difference, his striking contrast.

The Ottomans themselves were no strangers to Europe's battles and conflicts. There had been increasing tension in the Balkans since the early 1900s. The First Balkan War

erupted in 1912. Bulgaria, Serbia and Greece were on the way to declaring independence, one after another, each country fuelled by a wave of nationalism. Meanwhile, the Muslim-Turkish rulers of the Ottoman Empire had been developing close ties with the ruling elite in Germany. One particular Ottoman official was quite adamant that the country should be on the side of the Kaiser. His name was Enver Pasha—a name that not only Turks and Kurds would remember for decades to come, but also Armenians, many of whom would soon after lose their homes, lands, families and lives.

The Germans were keen to keep the Ottomans loyally on their side. It suited Kaiser Wilhelm to play the magnanimous role of "the protector of the Muslims". The Ottoman military was not the juggernaut it had been in its glorious days but the land itself was of strategic importance. The turning point occurred late in the summer of 1914 when a secret treaty was signed between Turkey and Germany. Only five Turks knew about it, among them Enver Pasha. It was his great wish to see the Sultan and the Kaiser uniting forces against the British and the French, and so the Ottomans joined the Central Powers.

There were, however, other Ottoman officials who fervently opposed the idea. These officers were alarmed that things were happening too fast and critical decisions were being taken without proper discussion. One of them was Rifat Pasha, the Ottoman Ambassador in Paris. A

born diplomat, he stated with some urgency that an alliance with Germany would bring only catastrophe and the best thing to do was to remain neutral. He wanted his nation to steer away from the madness that had the world in its grip. Rifat's words fell on deaf ears. Soon, his voice faded away and Enver's voice became louder and louder.

I have often wondered about this detail. How is it that a few individuals can decide a nation's fate? How could a handful of people possess this much power—uncontrolled, unbalanced and unquestioned? Certainly there were other factors that paved the way for the Ottomans' entry into the war. Yet it wouldn't be an exaggeration to claim that many political verdicts of crucial importance, including those involving a decision as tragic as war, are not the outcome of long-planned, well-calculated strategies, but emotional and personal judgements of a few fallible minds. In the end, not only in the Ottoman Empire but throughout Europe and beyond, a small number of men would decide the fate of millions.

In lands of collective amnesia, such as Turkey, women are the bearers of memory. It is women like my Cicianne who have shouldered the responsibility to remember. They hold the keys to oral history and are the custodians of cultural continuity, transmitting knowledge and wisdom from one

generation to the next. Women are also wordsmiths—narrating legends and folk tales, reciting poems, speaking in riddles. Then why is it, I ask myself, that though women have been dominant in oral culture, their presence in written culture, especially in "highbrow literature", has been so limited? For even though there are great female writers today, just like yesterday, the world of culture is dominated by men. No wonder, then, that when an anthology of Turkish writers and poets was published in Turkey, out of the 1,000 names included only 90 were women. Female voices constitute nine per cent of the literary establishment in Turkey. When that number goes up to ten we will call it "progress".

I dived into the ocean of stories not because I dreamt of becoming a novelist. I didn't even know such a thing was possible. But books mattered to me. Greatly. I never thought about how they were written or considered the fact that there were real people behind them. I craved the stories inside them. I was an only child raised by a single, working mother. I spent my early years close to a traditional, superstitious grandmother who, among other things, was a healer. She introduced me to a magical dimension of life, which was not bound by pure logic.

I started writing fiction at the age of eight. It all began with a turquoise notebook, a gift from my mother who was

worried that I talked to imaginary friends too much. She must have thought that if I could keep a diary and get used to writing down all the things that I did every day, I would be more firmly rooted in reality. But I saw it differently. I thought my life was too boring to write about. So I began recording in that diary things that had never happened and people who didn't exist. The journal that my mother had intended to ground me in reality became my window onto storyland.

Books kept me sane and glued my pieces together. I drank the stories I came across, both written and told, with an unquenchable thirst. I made up new ones of my own. In time I began to see my imagination as the only continuity in my life. And in order to keep imagining, I needed words. I yearned for nuance, too.

After the First World War, around the time Turkey changed its alphabet, another major cultural transformation was under way. Words derived from Arabic and Persian were excised from the language. Hundreds and hundreds of them. Such was the extent of the purge that if you place an Ottoman dictionary next to a Modern Turkish dictionary, the latter is around half the size of the former. The modernist elite believed that if there happened to be two words for roughly the same thing, the old one should be discarded. They wanted Turkey's language to be ethnically pure, and

therefore got rid of the Arabic and Persian components of our vocabulary.

Hundreds of words were plucked out of the Turkish language between the two world wars. Nuances of meaning have been lost. When our vocabulary diminished, our imagination shrank too. Philosophy and literature, fields that depend heavily on subtlety, suffered the most. Like everything else in Turkey, language became polarized and politicized. Depending on the ideological camp you feel attached to, e.g. conservatives versus Kemalists, you could use an "old" or a "new" set of words.

My writing is replete with all kinds of words taken from across the board. But I have had to do some digging, learn the Ottoman script and study my mother tongue as if it were a foreign language. It wasn't enough to be able to say "blue" or "green" as I sorely needed the hues in between. Most of those words had disappeared, since they originated from Persian. So, time and again, I was pulling the words out of the pits where they had been buried, shaking off their dust and incorporating them into my novels. Language is organic, an open-ended journey. It should only be enriched, not impoverished.

Some nationalists have been upset with me for my usage of ethnically "impure" words. Some conservatives have been upset with me because of the sexual and political themes that I have dealt with. And some Kemalists have been upset with me because I am interested in spirituality

and mysticism, which they regard as backward. Turkey is a land of quarrelling, clashing collectivist identities. In such a setting it is an ongoing struggle to be and to remain an individual.

Rather than "purity" and uniformity, I defend cosmopolitanism and hybridity. Rather than sameness, I am at home with diversity. My writing combines the Western genre of the novel with the Middle Eastern and Eastern modes of storytelling. I strive to bridge the gap between oral and written culture. I write in both English and Turkish. The commute between languages, cities and cultures inspires me endlessly. I refuse to pluck words out of language just as I refuse to reduce any human being to a single, monolithic identity. Literature harbours a strong desire to transcend frontiers—be they boundaries of class, religion, nation or gender. If our imagination is not going to do that, if stories are not going to do that, what else will, what else could?

There are so many questions about the past that the sixteen-year-old me never thought of or cared about but the forty-year-old me would have loved to ask Cicianne. Yet even if she had been able to answer me in earnest, the story would remain partial, incomplete. The First World War, like a kaleidoscope that offers a different truth at every glance, will mean different things to people of different nationalities. It

is only when we take into account all of these voices and aim to move beyond nationalistic rivalries and cultural dogma that we can attain a better understanding of this most fascinating slice of our shared history.

1. *konak*: A large house or mansion, usually dating back to Ottoman times.

CLARITY

NoViolet Bulawayo

NOVIOLET BULAWAYO won the 2011 Caine Prize for African Writing and the 2013 Etisalat Prize. She was shortlisted for the 2009 SA PEN / Studzinski Award, the 2013 Man Booker Prize, the 2013 Guardian First Book award, and was a finalist for the B&N Discover Great Writers Award. She was also one of the National Book Foundation's '5 Under 35' in 2013. Her work has appeared in *Guernica*, the *Telegraph*, *Callaloo*, the *Boston Review*, *Newsweek*, and the *Warwick Review*, as well as in anthologies in Zimbabwe, South Africa, and the UK. She is currently a Wallace Stegner Fellow at Stanford. She was born and raised in Zimbabwe.

ON 25 MARCH 2010, Zimbabwean visual and installation artist Owen Maseko holds an exhibition at the National Gallery in the city of Bulawayo. I imagine the attendees dragging around with reluctant steps like they are entering a place of dread, heads bent as if they will eventually drop off like overripe pawpaws and roll away, the eyes never to look at what they have come to see. I imagine bodies so tense you could shatter a glass on somebody's back and they would not feel a thing, women's arms crossed just beneath the breasts, men's hands clenched tight inside trousers pockets, fists so taut they could split at the seams. I imagine the kinds of faces you would duck across a street to avoid because you wouldn't know what to say to them—solid masks glazed with pain so proper, so charged you could touch it and sear your fingers. I imagine a well-built young man reaching for the wall to balance himself, digging into it with his left shoulder, but, because something in him refuses to be steadied, sliding down until he is a heap on the cement floor, shoulders heaving in sobs. And, somewhere far away, in Matabeleland, the western

region of the country, in the bushes of places with names like Plumtree, Lupane and Tsholotsho, where I was born just a year after Zimbabwe's independence from Britain, I imagine bones stirring in mass graves. Broken bones, smashed bones, desecrated bones, wronged bones, all rising as if they have heard their forgotten names read in a voice so loud it penetrated the earth.

The voice is Owen Maseko's, whose exhibition addresses, through installations and graphic paintings, some of which depict President Mugabe and members of the army, the massacre of an estimated 20,000 Zimbabweans by an elite unit of Korean-trained soldiers between the years 1983 and 1987. The massacres, commonly known in Zimbabwe as Gukurahundi, affected the Ndebele regions of the country, home to Zimbabwe's second-largest ethnic group. Years and years later, the atrocities have never been redressed, there has been no accountability by the government and perpetrators, there has been no justice for the surviving victims, no monuments to honor the dead; there has been nothing. By holding his exhibition, Owen Maseko has been provocative on at least two levels: he has publicly broken a sealed silence, and through the specificity of his art has pointed fingers right at the regime for its role in the atrocities. It is more than enough reason to get arrested.

Like many Zimbabweans, I am not shocked by Owen's arrest; it is, after all, 2010, the closing year of a decade of

government repression. Citizens and active members of the opposition who criticize the government to the extent that they are perceived as threats have been routinely subjected to illegal arrests, intimidation and torture and, in a few headline cases, murder. The news of Owen's arrest blazes across the Internet—it's emailed, blogged, tweeted and Facebooked by concerned Zimbabweans and sympathizers. I too join the online conversations; this is where those of us in the diaspora have taken to following and making sense of events in our country. We were here, for instance, during the illegal arrest of human-rights activist Jestina Mukoko, who was kidnapped from her home in 2008, during the arrests of too many members of the Movement for Democratic Change (MDC), Zimbabwe's main opposition party, during the torture of civilians in the 2008 post-election violence. The Internet is our other village; on it we talk freely about what we most probably would not dare talk about were we on the ground.

Along with most of my countrymen, I am disturbed and angered and grieved by every crime against Zimbabwe's people, but somehow Owen Maseko's arrest grabs me by the throat, and squeezes. Owen is an artist, like me, and this common ground makes his ordeal even more personal. There is more to our connection: at the moment I am studying for my MFA degree at Cornell University where I am working on a novel that grapples with the very beast that Owen is being persecuted for. One of my characters,

Bornfree, is a victim of Gukurahundi. Bornfree's father, Sabelo, a schoolteacher, is killed alongside his own brother and other villagers after being first made to dig a mass grave and then stand in it before being shot. We encounter Bornfree, now a young adult and activist, fighting against the same regime that murdered his father and uncle. It has not been necessary to use a lot of imagination to come up with Bornfree's narrative; versions of it have filled my childhood. It is, after all, the story of my people, the Ndebele, who were the targeted victims of the massacres.

After working on numerous drafts I eventually drop Bornfree's backstory from the book. It is too large and overwhelming a narrative, and it deserves to be a novel of its own. I come to understand that my project, which will eventually be known as *We Need New Names* when I publish it a couple of years after I graduate from Cornell, does not have room for this gigantic thread, at least in ways that would allow me to do it justice. It is thus that I make the choice to keep only Bornfree (who himself gets murdered for his activism) and shelve the Gukurahundi narrative, but of course I know that it is a subject I must and will one day return to; it is more than an obligation to bear witness to this ignored part of Zimbabwean history. In the meantime, the arrest of Owen has significance for me as someone working in the territory that has got him in trouble—it is a message about what is not acceptable in the telling of the Zimbabwean story.

Every socially engaged artist must at some point face defining moments when she must reckon with forces in the world around her, grand or small, and must—even if it's only the stones that know this—take a stand. This explains why Ngugi wa Thiongo renounced writing in English in the late '70s and continues to work in his Gikuyu mother tongue for example, why Toni Morrison has consistently written about race throughout her career, why Carolyn Forshé has looked without flinching at human-rights abuses. But in 2010 I do not yet appreciate this—I have not quite reached that level of engagement with what it means to be an artist, and if you were to probe me for what I do, I would not tell you with confidence that I am a writer.

Among other things, I cannot shake the feeling that perhaps I am making a mistake by being in a writing program instead of law school, which is what my father and family back in Zimbabwe believe I am doing. I have all along kept my writer's aspirations private, even imagining that a switch might flick within me so that I would go on to enroll in law school after the termination of my first graduate degree and finally study what I came to the United States to pursue when I left home for college years ago. But the switch never flicks in the end. Although I am not comfortable disappointing my family, I know I could not face myself if I were to go against what is in my heart, even a heart mired in hesitation. Still, I am just not yet at ease with my writer self and, while I am enrolled in a reputable

creative writing program, the fact that I have not published a single word means, at least to me, that I do not have the license to claim that writer self. I remember that for a while I resist calling my work in progress a novel, and whenever I am pressed to talk about what I am working on I call it a "thing". So much goes into naming and calling, and for me the word "thing" makes my project more approachable and less intimidating—after all, I have not written a novel before, so who I am to speak about writing "novels"?

All this is to say that the 2010 arrest of Owen Maseko finds me at the very, very beginning of my writing career and looking to make sense of myself, a novice trying to find footing. But of course life certainly does not always knock on your door to check if you are ready before entering with its sacks of challenges. When the arrest of Owen Maseko comes to my door, it is the first force that shakes my slumbering core. My writing, all along a solitary endeavor, suddenly feels connected to my community in more ways than I have imagined. As James Baldwin writes in his 1970 letter to Angela Davis, "If we know, then we must fight for your life as though it were our own… For, if they take you in the morning, they will come for us at night." I understand that the arrest is beyond Owen, that it is a threat to my own freedom of expression, as well as the art of every Zimbabwean who confronts the Gukurahundi or any other topic that our government deems unacceptable.

In my response to Owen's incarceration, a poem entitled 'For Owen', I go beyond the immediate event and comment on the larger picture of Zimbabwean repression in lines such as:

...like nobody didn't teach him [Owen]—didn't tell him
Zim is a land of silent silence,
where they edit expression on final cut pro
with police whips and guns and prisons
people living hand to mouth,
famished for rights, for freedom,
for the sound of their own true voices
see us walk like zombies in Zim, like
paralyzed by fear of the state in Zim
we could flee our shadows in Zim,
we see nothing, we hear nothing in Zim
let them silence us, beat us in Zim, like
what does freedom matter in Zim?

I publish the poem on a blog I keep at the time, which has been largely devoted to my responses to the Zimbabwean situation. I post it on Facebook, too, where I hope it will be shared among Zimbabwean circles. At this point I know that 'For Owen' is not just for Owen alone (who at the time is definitely not seated behind a computer, ready to read the poem and perhaps, if he is moved enough, respond to me)—it is also for the regime that daily continues to trample

the rights of Zimbabwean citizens. 'For Owen' is for my people because we must speak even as change refuses to come, 'For Owen' is for my fellow artists so that they may continue to create in defiance, 'For Owen' is for myself, so that I never choose silence. 'For Owen'—it gives me a clarity that I have not had before.

This clarity stays with me as I evolve from novice to determined writer, and while Owen is granted bail and faces trial for "Undermining the authority of or insulting the president" and "causing offence to persons of particular religion". The charge would be laughable were it not for the fact that Owen's freedom is on the line. Still, this does not stop him from working, and from being the face of those of Zimbabwe's artists who continue to create under the threat of censorship. I am inspired by Owen and many of Zimbabwe's other artists, both in and out of the country, who continue to carry the soul of our nation in its difficult times, who help keep our humanity intact. That we also share our various works on social networks—writings, spoken word, music, visual art, dance performances—speaks to me of our collective purpose, and seeing our work received by and meaning something to our countrymen and the world is the force that allows my writing to move forward. Difficult as this period has been, I will always remember with fondness and gratitude the efforts of artists like Cont Mhlanga, Peter Godwin, Novuyo Tshuma, Comrade Fatso, Batsirai Chigama, Christopher Mlalazi, Petinah Gappah, Iyasa,

Emmanuel Sigauke, Tendai Huchu, John Eppel, Tinashe Mushakavanhu, Outspoken, Tafadzwa Gwetai, Sandra Ndebele and many, many others for providing community and strength and sometimes support, for forging ahead when conditions, especially for those on the ground, were such that it may have been easier to lean against trees and find shelter from the sun.

Fortunately, the unrest and violence in Zimbabwe stabilizes after the regime and the opposition sign a power-sharing agreement that gives birth to a unity government. Robert Mugabe remains the country's President, and Morgan Tsvangirai, the MDC-T leader, assumes the position of Prime Minister. It is a sorry marriage of convenience, beset with problems that speak to an unfair union from the get-go, but the country still welcomes the move. Not only do we not have many choices, but we are worn out and just want to say goodbye to the terrible years. It feels like we have walked on thorns throughout the lost decade and this at least is a little bit of grass. Conditions on the ground are still hard, the most urgent being a failing economy, which affects people's livelihoods, but at least this change means we can stop holding our breath again, we can now rest on our buttocks again after sitting on just one butt-cheek for years, and on the edge of the seat at that. We can stand at full height and hope again. And live again, and dream again.

It is perhaps this stabilizing of conditions that encourages my writing to change. Whereas I've mostly been writing dense poetic prose that now makes me wince to read it, I feel my writing loosen up. It removes its belt and tie and kicks off its shoes. It cuts its hair and keeps a short, unkempt Afro, runs around in socks of different colors. For the first time I feel like I am not just writing, but speaking as well. I imagine I am addressing a party that is out on the streets of New Lobengula, my town, perhaps standing under a guava tree, with folded arms, processing my story through the ear. In order to tell the story to full effect and reach the listener while still sounding true, I have to tell it in my language, somehow. This is how I start actively to bring my native language, Ndebele, into English, to have my sentences sound just like they would strike an Ndebele ear if they were translated. Writing this way, I am delighted to find, captures my full and specific experience and allows me to say things that would otherwise remain unsayable. Removed as I am from my homeland, and living in a space that—while being rewarding and important in giving me the opportunity to pursue my art—still reminds me, always, that there are people at the center and that I will never be one of them, my decision feels like a liberation, an affirmation of a self that is not always able to find voice. When I write in this new mode, I feel like I am writing on my own terms.

I regret that no one taught me this crucial lesson in my early English instruction. Our education system, adopted

from the days of British colonial rule, did not allow us much freedom where language was concerned. The English we used remained standard and inflexible, never mind that we only encountered it in school and did not take it home with us—at least it did not happen in the type of neighborhoods I grew up in. This meant we could not have an easy relationship with the language, and when it came to writing creatively it kept us on leashes that could only allow our imaginations to go so far. Today I shake my head when a young writer emails a story that is written in the wrong English, the English that, because it does not come naturally to the storyteller, feels contrived and breaks the story's flow. It is my prayer that these young writers wake up to the magic of their true voices, that they realize that their languages, too, are enough.

In my novel *We Need New Names*, Stina, Darling's childhood friend from Paradise, observes that "a country is a Coca-Cola bottle that can smash on the floor and disappoint you". The intuitive young boy comes to this knowledge from watching his country come undone. One wishes this part of the story were fiction, but unfortunately it is not. It is also unfortunate that it is the story of a lot of countries today—we simply have not figured out how to live. Still, a country's story is impossible to fit in Coca-Cola bottle; telling it is an enormous task, and cannot be managed

by a single voice and in a couple of hundred pages. I am very much aware that in *We Need New Names* I have told only a small fraction of the Zimbabwean story, and what is more, I have also chosen to voice what to some may not seem like my story to tell, being that I have not lived in Zimbabwe in the past fourteen years. At the end of the novel, Darling, the protagonist who has left her unnamed country for the US, connects with Chipo, her childhood friend from Paradise, via Skype. The conversation occurs at the height of the country's crisis, and Darling expresses her anguish at what has become of her homeland. Chipo, however, has a different opinion:

"I know it's bad Chipo, I'm so sorry. It pains me to think about it."

"What is so bad? Why are you feeling pain?" Chipo says.

"What they have done to our country. All the suffering," I say.

"Well, everywhere where people live there is suffering," she says.

"I know. But last week I saw on BBC—"

"But you are not the one suffering. You think watching on BBC means you know what is going on? No you don't, my friend, it's the wound that knows the color of the pain; it's us who stayed here feeling the real suffering so it's us who have a right to even say anything about that or anything and anybody," she says. Her flippant tone comes out of nowhere

and slaps me in the face, just taking me by surprise. I am so shocked I don't know what to say.

"What? I can't—well, it's my country too. It's our country too," I say. Here Chipo laughs this crazy womanly laugh and I shake my head and think to myself, what the fuck? Where is this even coming from?

"It's your country Darling? Really, it's your country, are you sure?" she says, and I can feel myself starting to get mad. I hover the mouse over the red phone button, wondering if I should just click it and hang up because really, I have no time for this. When I look up my eyes meet the eye and I let go of the mouse.

There are times I have felt like Darling in this particular instance, for, just like her, and like many Zimbabweans in the diaspora, I have experienced the country's crisis from the outside. I am aware of the privilege that comes with distance; I know I have been spared from living through all the hardships that my countrymen have suffered. I felt this in the especially hard times following the 2008 election, when people moved from the euphoria of the promise of change to the uncertainty that came with the post-election repression. I remember a conversation I had with my father around the time. Not long before that, and up until election day, his voice had been full of sunshine as he spoke of a change of government with a conviction that sounded so true I mostly believed it.

When I speak to my father after the election, after the people have waited and waited and waited for the results until they almost go mad with suspense, my father's voice sounds far away, bleached of the laughter and confidence that have always been a part of him. When I ask him what is going on, he says, "We don't know any more. And the people are being beaten like hell in the rural areas." I grip my cellphone tight at the new crack in his voice; I have never heard my father sound like this before and I am caught off-guard—I have no idea what to say to him. As in other times, far too many of course, that I have not been able to do anything, I am riddled with the guilt that comes from being far away, from being protected from day-to-day challenges that my family and countrymen have to endure. When I write especially the hard parts of their experience, parts that I know come from the pain that real people are living through, tears hold their breath in my eyes.

Perhaps I include the Skype conversation in *We Need New Names* for this reason: it is my way of saying, "I know—I know", my way of trying to show that I am aware of the position I occupy. It is my way of washing my hands in a text that I consider a love letter to my people because while it comes from a difficult time, it exists mostly because of my love for my country and people. Even with the limitations of distance, I am still Zimbabwean, and moreover, it seems to me better to speak than not to speak at all, knowing

that one day decades from today, a century from now, the future generations of my homeland will look back at this recent lost decade and want to feel its pulse. I would like to spare them the experience of my generation, looking back in search of the Gukurahundi. I do not wish for them to find silence; I wish them clarity.

THE COMMUNITY
OF SEALED LIPS:
SILENCE AND WRITING

Erwin Mortier

Translated by Paul Vincent

ERWIN MORTIER (born 1965) made his mark in 1999 with his debut novel *Marcel*, which was awarded several prizes in Belgium and the Netherlands, and received acclaim throughout Europe. In the following years he quickly built up a reputation as of one the leading authors of his generation. His novel *While the Gods Were Sleeping* received the AKO Literature Prize, one of the most prestigious awards in the Netherlands, and is published by Pushkin Press alongside *Marcel*, *My Fellow Skin* and *Shutterspeed*.

M Y GRANDMOTHER called herself a substitute child of the Great War. She did not experience it herself, but if it had not broken out, she was wont to say, she would never have existed. A year before her birth in March 1919 her eldest brother, whom she never knew, died of Spanish flu. He was born in the summer of 1914 and succumbed to the disease in the spring of 1918. The duration of the First World War was his whole life.

There is only one photo of him, rendered thoroughly opaque by time, in which an infant with big eyes like those of an owlet looks into the lens. Actually I know no more about him than his death. When Spanish flu reached the flat country between Ghent and Bruges, where my mother's family had worked the land for generations, it attacked the lives of mostly children and young people, weakened as they were by the occupation and the scanty food rations. Older people had more resistance to the virus, and most survived it.

Every day children came to my great-grandparents' farm begging for food, bread, milk and eggs. Children of day-labourers, indigent weavers, small farmers who

had to scrape a living from poorer soil than the rich earth gleaming with clay on which my family grew their crops and reared their livestock. My great-grandmother dipped the children's cups and mugs into the jugs containing the morning milk fresh from the cows, but first she blew aside the cream which had floated up to the top. Cream meant butter, and butter was destined for the Germans, as was the grain, as was the meat. There was hunger everywhere.

My grandmother told me that when the flu struck, the dead of the previous night were carried through the farmyards and orchards to the side of the road, almost all of them children. A cart drawn by horses—old horses, since all the strong ones had been requisitioned by the Germans—came to collect the bodies. The speed and scale of the deaths were too great to be able to give everyone a decent funeral, and there was also the danger of infection. Nor were there enough planks to make coffins for all those bodies. Many children, said my grandmother, were simply put into the earth in their pyjamas or nightgowns, or in a shroud of bed sheets hastily sewn together.

She told me what her mother had told her about that time and what she could have told her children, if her life had not been so imbued with the shame two wars had engendered in her, if there had not been so much that she preferred to keep to herself: things that I sensed were charged, gaps in the narrative universe that embraces every family, because we never come into the world truly naked.

As soon as we leave the womb we exchange the amniotic fluid that has surrounded us for nine months for a sea of stories in which we are submerged long before we are aware of it. And, just as we learn the hard way that it is not sensible to touch a hot stove or a frozen door handle, we gradually realize that silences occur in the stories in which we are embedded that are equally untouchable. Memory too has its sore spots.

My great-grandparents cannot have allowed themselves much time to mourn after the death of their eldest child. There are scarcely ten months between the death of my grandmother's eldest brother and her own birth, four months after the end of the war. A farmer without progeny is a farmer without a future. My grandmother knew she was the fruit of a second attempt, and what's more an only half-successful one. True, her birth brought new life, but she wasn't a boy. She was not the son who would one day take over the farm from my great-grandfather and continue the work on the land for another generation.

That son was born a few years later, in 1922, but I never knew him either. He was killed in January 1944 in the Ukraine, on the Eastern Front, as a recent recruit in Hitler's army, during the liberation of Berdichev, the town where three years before the Nazis had murdered 30,000 Jews. A comrade-in-arms took him, badly wounded in a grenade attack, to a field hospital and left him there as the Red Army approached.

My grandmother hoped that there was someone to tend his grave over there in Russia. She was always busy scrubbing the graves of her family members with bleach to fight the moss. I never dared tell her that her younger brother may never have had a grave. Her older brother did have a gravestone, but there was no body under it, since the child had been buried together with many others. The remains of her younger brother probably lie somewhere in a Ukrainian field or meadow, without a cross or any other sign, and I just hope he was already dead when the Russians reached the hospital, because when they found wounded soldiers in German field hospitals they usually shot them.

Perhaps my grandmother realized all that too, but she said nothing about it, and nor did I. I had understood from an early age that the war was one of those sore spots in the family memory which I would be well advised not to prod at.

As a child, war was a word I could not link to any concrete memories or meanings. It seemed to evoke mostly silence, the silence of hidden mourning, the silence of loss and bereavement, of shame and guilt, and not only at home, in my first nest, but virtually everywhere.

The veterans of the Great War also seemed to want mainly to be silent. On 11 November they gathered in the church square around the monument to the fallen, their coat collars covered in medals, their fingers raised in a trembling salute as the national anthem rang out. After

the ceremony they made for the pub and silently drank their beer or gin.

"When I saw what I'd done, I felt ashamed," said one of them, who was invited by the head teacher to come and talk at school about his time at the Yser Front. He told the same story every year. One night he was ordered to leave the trench and advance into no man's land for a counter-attack. He threw a grenade ahead of him and later saw the havoc the thing had wrought: four dead soldiers, Germans, cowering in a bomb crater. "Lads like me," he said. "Farmers' sons like me perhaps."

However loose-lipped he was compared with the other veterans, I felt that there was much more about which he was silent. His voice regularly faltered because of his inability to capture the scale of the devastation, the violence, the stench and the death in his limited language. And there was also astonishment at the waste of so much good agricultural land, possibly just as shocking as the human slaughter, I suspect, for someone who saw himself as a scion of the aristocracy of the earth, the proud farming class that fed our nation.

2

There is a lot of silence in my fatherland, where there is much that cannot be said. Belgium is a land of *non-dits*, as the French call things that are taboo. The visit of that

1914–18 veteran was also a way of not having to talk about the following war, which had divided communities into those who collaborated with the occupying forces, like my grandparents, those who resisted and the countless others who compromised in order to survive. No one felt much like looking back afterwards. Our head teacher had fought in the Resistance in the Second World War. Now he taught the grandchildren of collaborators to read and write just the same as the descendants of those who had fought on the side of the angels, or those who had tried to survive the Nazi occupation as unobtrusively as possible.

Social cohesion, being able to live together as harmoniously as possible, is the aim of a community, not necessarily coping with painful and complex, even paradoxical truths. It is a strategy that helps us to return to a more or less normal existence, but it also carries a price. The past cannot die in the act of remembering. It cannot become truly past because it is not given a story, and so remains hanging, unresolved, in silence—in the community of sealed lips.

3

As a child I was so fascinated by words, by language, precisely because on my mother's side so much was cloaked in silence. Where matters are cloaked in silence, it is difficult for the silence to keep quiet. Everything seems irradiated

by secret speech. Sometimes I fantasized that the long lines of poplars, which divide up the vastness of the sky and the land in my native region into tolerable rooms, whispered when the wind brushed their crowns. I thought they whispered because so much whispering went on in the grown-ups' world. My mother made fun of me because in the evenings before I went to sleep I would talk to the pine trees from my bed, the line of blue-green pointed hats outside the window of my room, in which the wind, unlike in the poplars on the street side, produced a soft whistling: the song of countless pine needles trembling in the breeze.

Sssh, sssh, they said, hush now. Sssh, sssh, like someone pouting their lips to lull a child to sleep. My mother laughed at me because, according to her, trees couldn't talk. The trees have no voice, she laughed. But if our voice is no more than air causing two elastic bands to vibrate in our pharynx, why should trees not be able to speak when the same air that we exhale in speaking plays upon their foliage?

As children we only become human when we learn to listen to language as language, when we begin to realize that the words of the beings and things that surround us are not properties like their colour, their smell, their form, but sounds that we produce and teach each other in order to make ourselves understood by ourselves and each other. It is the moment when we bark instead of saying "meow" when asked what sound a cat makes.

That playful child's lie symbolizes a ritual rupture of the unity of world, word and body. It marks our real birth into language, which is first and foremost an experience of alienation. Lying opens the spaces between words and things, between words and ourselves, our desires, our fears, our motives. The lie is the keyhole in the door beyond which are the dim chambers of the inner self—the other person's and our own. Of course I knew as well as my mother that trees do not speak, but by imagining that the whole of nature was capable of language I could cling for a little while to the illusion that the unity remained intact.

It was a happy household that I grew up in, both in my parents' home and at my grandmother's, with fancy-dress sessions under the beams in the attic, where the clothes of our great-grandparents and other garments awaited us. We looked at tadpoles in glass bowls, played hide-and-seek in the orchard and caught butterflies. For our birthdays my grandmother baked enormous cakes, architectural marvels of dough, chocolate, puff pastry and whipped cream. In short, we had everything that belongs with a carefree childhood, not least buckets of unconditional love, warmth and affection.

But there were also fears, vague fears that could take hold of me particularly at night. I don't know how many times my father (my mother took care of the talking trees) opened the wardrobe in my room when I was little, to chase away the bear or dragon that had hidden in it. My father

felt that I had too much imagination. I would be better off spending a little less time with my nose in strip cartoons or watching *Star Trek*, he thought.

But the bears and the dragons were figments of my imagination. The fears that were besetting me had no shape—that was precisely what made them frightening. With bears and dragons there was still a possibility of communication, in view of my dialogue with the local flora. I was still too young to realize that where much is kept silent, silences become wandering emotions, exiles in search of something to hold onto, of a body to harbour them and perhaps finally give them shelter in language and narrative. I heard them and they frightened me. Perhaps they were searching for me.

4

What if it had all turned out differently? What if the owlet had not died of Spanish flu? What if my grandmother had not had the feeling that she really ought to have been a boy and that her birth had been a disappointment to her parents, however loving they had been?

What if her father with his horse and cart had not been dragged along by the Ghent-to-Bruges train in 1928, because the horse started rearing on the level crossing and refused to move ahead? What if my great-grandmother had not had

to leave the imposing farm because, as a widow with two small children who demanded all her attention, she could not possibly also head a flourishing farming business? What if she had not died of bone cancer a few years later and left two orphans behind: two teenagers alone in a world still licking the wounds of the Great War, plagued by an economic crisis and increasingly in the grip of political movements which were soon to spread their regime of gruesome terror?

Would my grandmother and her younger brother have been less susceptible to the vision of a world ruled by purity and harmony if my great-grandfather had still been alive? Would my grandmother have had a different life, without silences and shame, without mourning that could not express itself, without gnawing feelings of guilt, and would her brother not have ended up in a grave in Russia, in the uniform of an SS Grenadier?

I don't know, I don't know. And there is no one left to answer those questions. My grandmother has been dead for six years and perhaps she would not have answered anyway. On the few occasions that I asked her about the past, I found myself sounding very much like an inquisitor, and I heard and felt her shame. What right did I have to drag her before the court of history? No one is totally transparent to themselves; no one can always give equally clear reasons for the choices he or she has made. I would have liked her to say: "I made mistakes, errors and I have to

live with them." But she was too proud. Probably she would also have had the feeling that by forswearing the past she would have been spitting on her brother's grave, however much incomplete mourning continued to overshadow her own life. She was scarcely twenty when the Second World War broke out. She lived to be ninety. Seventy years spent cherishing the memory of a dead relative who embodies the shame of the family is a long time.

Shortly before she died she gave me a sheaf of family papers. She said I was entitled to them and that she knew I would look after them. There are no secrets revealed in them. The sheaf contains her diplomas for French and German and dressmaking—she was proud of having an independent income as a dressmaker apart from her husband's, and of speaking a number of languages. The daughter who should have been a boy obviously wanted to prove that she was a match for men. She had also kept the bills for the funerals of her father and mother, and for the Requiem Mass she had dedicated to the memory of her fallen brother. There are also a few letters of his from Russia—insignificant letters from a green youth who in his own words hoped to defeat the Communists for the greater glory of Flanders. His last letter dates from a few weeks before he was felled by the fatal grenade.

I filed all the papers away in an archive box. Now and then I take them out and hear them whispering. They don't say much. I've long since stopped talking to the trees and

the fears of the past have evaporated. Writing, I have learnt, is not intended to solve riddles. It is speaking and silence at the same time, my way of dealing with the community of sealed lips. Not by breaking them open, but by giving them a farewell kiss and making their silences audible.

COOLIES

Xiaolu Guo

XIAOLU GUO was born in China and now lives in London. She is the author of: *Village of Stone*, shortlisted for the *Independent* Foreign Fiction Prize and nominated for the International IMPAC Dublin Literary Award; *A Concise Chinese-English Dictionary for Lovers*, which was shortlisted for the Orange Broadband Prize for Fiction and has been translated into twenty-four languages; *20 Fragments of a Ravenous Youth*, which was longlisted for the Man Asian Literary Prize; *UFO in Her Eyes*, recently made into an award-winning film by Xiaolu herself; and a collection of short stories, *Lovers in the Age of Indifference*.

I. COOLIE

A HOWLING JANUARY wind sweeps across the English Channel as we drive along the flat Normandy coast, heading towards Flanders. My companion Li Ling, a fifty-two-year-old Chinese woman from Qingdao, sits silently in the passenger seat. We first met in China fifteen years ago, when I taught her daughter in art school. It feels strange to be in France with her. She has barely spoken all morning and I can see that this brief trip to France is a chance for her to escape the burdens of family life and a monotonous government administration job. But that is not its main purpose. Li Ling is the granddaughter of one of the Chinese labourers who died in the Somme during the First World War. She has come to find her grandfather.

The beach is empty, the sand grey. Snow starts to fall. Not far from Calais we stop at a lone seafood stall. A lavish display of cooked shrimps, smoked herrings, crabs, oysters, snails lies on a bed of seaweed. Two men, with wind-scorched faces, are pulling lobsters out of ice containers with pale, wrinkled hands. They look as ravaged and weathered as

the soldiers you see in black-and-white photos from the First World War. The fishmongers are locals, probably from families who have lived here for generations. I wonder what their great-grandfathers would have made of the Chinese who came to this area in 1917. What would they have thought of those Chinese peasants, starving and homesick, working and wandering in their homeland?

Coolie, or kuli (the Chinese characters are written as 苦力) means "bitter labour" or "bitter strength". Bitterness is an important and well-used concept in Chinese. It appears in many old sayings: *sugar cane has a bitter end*; *strong medicine ought to taste bitter*. In China, bitterness is something that has to be accepted. It is part of life. My grandmother and my mother were always telling me that I mustn't fight the bitterness that came with our harsh life in a small fishing village in the south of China. Historically, the majority of Chinese have been labourers. The Chinese believe that hard physical work can keep one alive, therefore "coolie" is a neutral term. In the West, however, "coolie" carries all the negative connotations of imperialism and exploitation because it came to describe the virtual slaves who, from the eighteenth century onwards, were dispatched from China to serve the West.

The coolies of China went everywhere. They built the railways that crossed the American Wild West and went from the Arctic to Siberia; they worked in Peruvian silver mines and Trinidadian sugar plantations. You can find evidence

of coolies in the museums and histories of almost every country in the developed world. Yet there is one particular group of coolies who have been long ignored and almost entirely forgotten: the 100,000 contracted to the British Army during the First World War and sent from eastern China to the ashes and mud of the European trenches.

2. THE CONTRACT

Li Ling and I did some historical research before coming to France. Her grandfather was illiterate and so sent no letters home recounting his experiences. There were no other personal documents to recover. All we knew was that his Labour Number was 4621, given by the British government on the Chinese seashore before he embarked.

We had only the basic information that in the winter of 1916, after the massive losses during the Somme Offensive, the British government, desperate to recruit more manpower for the Western Front, approached the Chinese government. Britain's population at that time was 30 million, while in China half a billion were struggling to survive. For the West, this represented a bottomless pool of potential labour.

At the time, the Qing dynasty had just collapsed under the Boxer Rebellion. Two and a half thousand years of

the Chinese imperial system had plunged into a maelstrom of civil wars and regional army control. A dragon without a head, a sleeping lion. This was perhaps the weakest moment in contemporary Chinese history. Feng Guozhang, the ill-fated President of the Republic of China, agreed to supply Britain with "bitter strength". Self-effacing and voiceless in society, leading insular and culturally isolated lives, the average Chinese had no notion of what sort of war was taking place in Europe. Many had no idea they were going to help the British and French fight the Germans. All they knew was that they would labour abroad and get paid.

In 1917, thousands of coolies like Li Ling's grandfather were gathered in a handful of towns by the East China Sea. He was a nineteen-year-old from Hebei Province and had just got married to a servant girl. They had a ten-month-old baby. He had been seduced by the promise of earning one French franc per day and was told he would be at least ten miles from the firing line, nowhere near the Front.

A few weeks later, with a rising number of casualties on the Western Front, 40,000 coolies were also recruited by the French Army to dig trenches in northern France. After being sprayed head to foot with disinfectant, and having had their ponytails chopped off, these men were packed like cargo and shipped towards the West.

3. CRIME AND PUNISHMENT

After four months at sea, the coolies arrived on the Western Front. They were told to dig trenches and lay railway tracks in the blasting sea wind. Even for the time, their working conditions were inhuman. Their contracts demanded they work ten hours a day, seven days a week. I imagine Li Ling's grandfather, ragged and disoriented, blindly obeying the order to "Dig a trench!" on this bleak shore. It must have been confusing, since the depth of a trench was similar to the depth of a grave that might have been dug back in rural China.

Since Westerners found it so difficult to tell one Chinese from another, each coolie was given a number. Their fingerprints were put on file by Scotland Yard, which helped the British Army to deliver punishment for any crime these labourers committed. In his memoirs, Lloyd George notes the harsh conditions of coolies working at the Front. There was a strict policy of segregation. The labourers were not allowed into the military canteens or to mix with the civilian population, in particular white women. Outside working hours, labourers had to remain in their camps. A total of thirty-two camps were established on the Western Front for the "British Chinese Labour Corps".

A diary published by a British lieutenant, Daryl Klein, entitled *With the Chinks*, records what he calls the "Sausage

Machine" training centre where the Chinese were taught drill. He writes: "There is a rivalry among the officers in regard to the number of canes broken on the back, legs and shins, not to speak of the heads, of the defaulters."[1] For crimes such as gambling and fighting, transgressors were punished by anything from docked pay to imprisonment of between three and fourteen days. If a coolie fell ill, his wages were immediately stopped.

Despite such oppression, the coolies staged strikes against their insufficient food and working conditions. When the British Commander-in-Chief, Douglas Haig, learnt that No. 74 Chinese Labour Corps had stopped unloading supply vessels, he imposed order. A total of twenty-seven unarmed strikers were shot dead, thirty-nine were wounded and twenty-five taken prisoner. Ten coolies were executed—shot at dawn—for murder.[2] It is recorded that a coolie known only as "Anon 4976" committed suicide while under sentence of death rather than be executed by Western men.

There are no clear records of how many coolies died from the effects of hard labour and how many from punishment. All we have is the official British version of events which says that, by 1919, 2,000 coolies had died on the Western Front. Of course, Chinese historians have disputed the figure. Perhaps the figure of 2,000 refers to the number of gravestones scattered around Flanders. The actual figure, no one knows.

4. THE MEANING OF POPPIES

In China there is no Remembrance Day to commemorate the First World War. Seeing a Westerner wearing a red poppy, a Chinese person probably wouldn't know it was a symbol to remember soldiers who died in the war. For the Chinese, the poppy is associated with the shameful past of the Opium Wars (even though that is a different type of poppy). The small amount of British history I learnt in Middle School centred on the Opium Wars. My teacher was very clear: "How to understand British history? Two things—they invented Capitalism and they forced opium on China." Any Chinese who went to school in the '70s and '80s would have been taught these two facts.

It is a cliché that history looks very different depending on where you are standing, but it surprises me how often British people expect me to know their history back to front when they know little of mine. For an ordinary Chinese person, war means above all massacre. The most infamous example is perhaps the An Lushan Rebellion, during the Tang dynasty, which left 36 million dead. Some historians believe this to have been the largest atrocity in human history in that one-sixth of the world's entire population at that time was lost. More recently, the Rape of Nanking in December 1937 led to 300,000 deaths within six weeks. By February 1938, Nanking was a city of corpses.

For the Chinese, the period 1914–18 is more about the rise of Communism than the First World War. We think of 1917 as one of the most important years in the twentieth century. It was the year the October Revolution led by Lenin illuminated the sky in the East; the Chinese Communist Party was forming itself in the Russian style. Intellectuals from Beijing University such as Chen Duxiu and Li Dazhao became the first founding members of Chinese Communist Party in the early 1920s. The East was rising and trying to establish a new order on the ruins of feudalism and imperialism. These powerful ideas spread West. After the First World War, the Communist Party of Germany was founded in 1918, led by Rosa Luxemburg, followed by the Communist Party of Great Britain in 1920. Accumulated resentment was causing social unrest.

In 2002 I came to Britain because I felt I couldn't continue to work as an artist in China due to the strong censorship. But that doesn't mean I automatically became a Westerner. For me the First World War is still a European power conflict that happened a long way away. I feel much closer to the disorientated coolies who found themselves in Flanders than the wearers of poppies on Remembrance Day. And if poppies make me remember anything, it is that the people are still oppressed, and slavery still exists. Either inside the country, or abroad, we Chinese have been living as coolies, and we still are coolies. The national GDP growth

depends on this. But it is not only the Chinese. According to the International Labour Organization, currently there are 20 million men, women and children around the world in slavery. In the twenty-first century people are still sold as property, dehumanized, trafficked and subjected to sexual or labour abuse.

Even though the coolies are getting rich these days, the prejudice against China is still very strong. When Li Ling and I took the Eurostar from London to Paris, we encountered a group of Chinese tourists on the train. They seemed to be typical entrepreneurs, armed with smartphones and gold rings and Hermès watches. Then they brought out their plastic bags of raw leeks and sunflower seeds, loudly chewed away and spat out the shells of the sunflowers seeds on the floor. They might have come straight from the rice fields or the backyard of a shoe-making factory. The other passengers were visibly agitated but there was no exchange between them. It was as if the Western passengers and the Chinese belonged to different species.

5. CHRYSANTHEMUMS

The wind grows quieter as the day progresses. The sky turns blue, the sea calms and the waves soften. It is the second day of January 2014. As the sun begins to shine, the beach comes alive with families and dogs, as if they are

emerging from the festive season to set about the new year with vigour and resolution. We drive through their colour and noise into a small town of quiet cobbled alleyways, and pull up in front of a cemetery. Finally, we have arrived at Noyelles-sur-Mer. Li Ling gets out from the car with her freshly bought chrysanthemums.

Noyelles-sur-Mer is one of the graveyards where the largest number of coolies are buried. There are 842 gravestones carved with Chinese names, along with the numbers the coolies were given by the Labour Corp. Li Ling, holding her flowers, searches each stone for her grandfather. I help her, scanning those strange yet familiar Chinese names. After looking at about 300 gravestones, we find the right one. The stone is covered in moss, yet the man's name and number are clearly visible.

LI CHANGCHUN,
BRITISH CHINESE LABOUR CORPS 4621.
DIED 12TH JANUARY 1919.

I am surprised. So he died here not during the war but *after* the war! "How?" I ask Li Ling. She doesn't know. Did he die from a random explosion during mine clearances? Or from starvation? Or was he killed for desertion? There is no clue. Only some blackbirds flapping their wings in the distance. Then, beside Li Changchun's Corps number, I see this phrase: *Faithful unto death.*

I look away. I can't bear the hypocrisy let alone the indifference with which this phrase has been foisted on this man. My eyes wander along the rows of Chinese names. The inescapable wind buffets the graves, otherwise there is silence. I look back. Li Ling is carefully placing her bunch of yellow chrysanthemums on her grandfather's tomb.

1. Daryl Klein, *With the Chinks: In the Chinese Labour Corps during the Great War* (Naval & Military Press, 2009), p. 148.
2. Gerard Oram, *Death Sentences Passed by Military Courts of the British Army* (Francis Boutle Publishers, 1998), p. 211.

FEARING
THE NIGHT

Colm Tóibín

COLM TÓIBÍN is the author of eight novels, including *The Master* and *Nora Webster*, and two collections of stories. He is Irene and Sidney B Silverman Professor of the Humanities at Columbia University in New York.

L IKE MANY OTHERS who lived in Ireland, Lady Gregory spent the First World War in two minds, almost in two countries. Although her husband had been Governor of Ceylon and a Member of Parliament who took the Union of Ireland and Great Britain for granted, Lady Gregory, after his death in 1892, had slowly built up a set of allegiances to an Ireland that was coming into being. She had learnt Gaelic and translated ancient texts; she wrote plays on Irish subjects, including political subjects; she was one of the founders of the Abbey Theatre, which would produce only plays by Irish authors.

After her husband's death, she could easily have stayed in London, where she had many friends; she could have used Coole, his house in County Galway in the west of Ireland, merely for holidays. Instead, with the poet W.B. Yeats as a regular summer guest from the late 1890s, she made Coole into the centre of a new artistic energy which would have considerable political implications and results in Ireland.

Nothing, however, was simple. While Lady Gregory collected ancient folklore from her tenants at Coole, she also

made sure that they paid their rent on time. While some of her plays seemed to support sedition, she could also happily sup with royalty. In 1909, for example, while staying with Lady Layard in Venice, she wrote to Yeats: "The Royal Yacht is anchored off the Piazza and yesterday the Queen, the Empress of Russia and the Princess Victoria came to lunch here and were pleased and pleasant. There was a Russian Prince between me and your friend the Queen but she talked to me sometimes across him."

Lady Gregory spent the summer of 1914 in London, where she attended many parties and even lunched at 10 Downing Street beside the Prime Minister. She was back in Coole, however, by the time war was declared. Robert, her only child, did not join up immediately as negotiations over the possible sale of the estate at Coole to the Congested Districts Board were at a delicate state. He was thirty-three in 1914, a graduate of the Slade School of Art, married to an Englishwoman, Margaret Graham Parry, and the father of three children. Despite his Irish roots, it was clear where his sympathies lay. He had been to school in England and lived much of his adult life in London. Unlike his mother, he had no ambiguous loyalties. He believed wholeheartedly in the war effort. "Robert," Lady Gregory wrote to John Quinn in New York, "is in a tangle of trouble over the estate. We had agreed to sell when the promised Land Bill comes in, and now they say the war will put it off for years and the tenants are restless... All this troublesome

business makes it impossible for the moment for Robert to join the army, as he all but did."

Lady Gregory's diary, as she began to note down what the locals in rural Galway and Clare were saying about the war, gives us a sense of how remote the west of Ireland was from the empire. "An old man mending the sea wall at Burren," she noted, "says this was prophesied hundreds of years ago by Columcille, and it will not leave a man living in Ireland." Or: "Old Nilan says: 'Johnny Quinn of Duras was telling me that the English will not be put down till the time the sea will get dry.'" Or: "Old Martin Glynn says: 'They say the Germans will be coming here. If they do break in I suppose we must go on their side or it'll be worse for us.'" Or Old Nilan again: "A man of the name of Hartigan was telling me the Germans [have] things... the size of turnips, and they burst up and blow them through the elements." Or a basket-maker: "The Germans are a terribly numerous race... Whatever number of them were killed [under Bismarck] they would be coming next day as if out of the ground, the same as a second Resurrection." Or an old woman by the sea in Galway: "Isn't the Kaiser terrible to send his son out fighting till he got his death? A fine young man, it would have been better to have sent him on a pleasure trip to London." Or a working man: "There is a German family and we have one of them on the throne, and in Germany they've got another; and being cousins, as is the way with cousins, they have fallen out, and that's

the reason why we're at war." Or a piper: "In the Crimea they were not liable but to an odd day or two, but now they are fighting every day." Or a woman known as Mary the Dancer: "The Gipsies [meaning the Germans] are terrible; didn't they burn the three best towns in England; to break with Ireland they'll burn it the same as England, and put it up into the air."

Robert Gregory, it was always clear, would join the war effort at some point. "I told him," his mother wrote to John Quinn, "I had such confidence in his right judgement I would say nothing for or against, at least nothing of my personal feelings. Indeed I think in some ways it might be happier for him, but the worst is, once in the army it may be years before you can get out, and his painting would probably have gone to pieces by that time." Eleven of Lady Gregory's nephews also joined the army.

Having signed up in September 1915, Robert was transferred to the Royal Flying Corps the following year. In her journal Lady Gregory wrote: "The machines are single-seated, he will be alone, with a machine gun. He has splendid nerve and likes his work and is evidently thought a great deal of. I have always that background of anxiety, but try to go on as usual…"

Four of Lady Gregory's nephews died in the fighting in France. Another was killed at Gallipoli, and a grand-nephew was also killed in a battle near the Tigris. And Hugh Lane, the nephew to whom she was closest, was

killed in the *Lusitania* in May 1915. She was at Coole when she heard the news, with George Bernard Shaw as a guest, and Robert also staying. When Shaw asked her if there was anything he could do to help her, she noted in her diary: "I said I longed to be alone, to cry, to moan, to scream if I wished. I wanted to be out of hearing and out of sight. Robert came and was terribly distressed, he had been so used to my composure." Her diaries throughout the war, like many other diaries from that time, are filled not only with watchfulness and worry but with outbursts of the sharpest anguish.

By the time Robert began to operate as a fighter pilot, a great deal had changed in Ireland. Lady Gregory was at Coole at Easter 1916 when the Rebellion in Dublin broke out. Her letters are an interesting example of how quickly public opinion changed in Ireland, how swiftly people moved from being shocked by the Rebellion, or being openly opposed to it, to feeling a strange sympathy with its leaders. Just after the Rebellion, for example, Lady Gregory wrote to W.B. Yeats: "It is terrible to think of the executions or killings that are sure to come—yet it must be so—we had been at the mercy of a rabble for a long time both here and in Dublin, with no apparent policy." After the execution of the leaders of the Rebellion, including Patrick Pearse and Thomas MacDonagh, whom she had known, however, Lady Gregory's attitude changed. Within a few weeks, she wrote to Yeats again: "My mind is filled

with sorrow at the Dublin tragedy, the death of Pearse and MacDonagh, who ought to have been on our side, the side of intellectual freedom… It seems as if the leaders were what is wanted in Ireland and will be even more wanted in the future."

Like many other people in Ireland who had family in the war, Lady Gregory realized that, despite the involvement of more than 200,000 Irishmen in the war (130,000 as volunteers and the rest as professional soldiers—there was no conscription in Ireland), because of the Easter Rising, all had "changed, changed utterly" in the Ireland the troops had left in 1914. Over the next two years, as conscription was threatened, and many were released who had been interned after the Rising, a determination to separate from the empire became widespread, culminating in the landslide victory for Sinn Fein, which won 73 seats out of 105 in Ireland in the December 1918 general election.

But in the meantime, the war went on. In her diaries and letters Lady Gregory was watching two scenarios, one in her own country and the other in the country to which her son had given his loyalty. In this period, in her mind, as in the minds of many others in Ireland, the relationship between the local and the wider political world became gnarled, unsettled, shadowy, darting in many directions with each day's events. Thus Lady Gregory became alert to the change in public opinion in Ireland, following the news with close attention, but she also waited every day for news

of Robert. At the end of the war she wrote: "Often I had wondered, or there had been speculation in the background of my mind, for I tried to put away the thought, as to how one would hear, would bear the news that had become possible from the day Robert joined the Flying Corps. Every evening I had been thankful that no such news had come, every morning I had prayed for the safety of my child."

The war itself came also as two scenarios. One was filled with stark horror and worry; the other meant that all complexities were in abeyance. Since Robert Gregory had gone to war, it meant that the affair he had been conducting with a friend of his wife's, and which he had told his wife about in 1915, no longer mattered, or at least was not the most important thing. All the emotion around it seemed pale compared to the danger he was in. Robert had been cruel and thoughtless; he had seemed to want his wife to know all the details of the affair, to rub her nose in it. She, in turn, had confided in her mother-in-law. Both women had judged Robert harshly; relations had been difficult, at times chaotic. The air was filled with accusation. The war had simplified everything. Robert had got away from his lover and from his accusers. Emotions in these years could be reduced to what was essential. Margaret, Robert's wife, wanted him back, as did his children. With his mother, they waited for news every day. The war had got him away from being blamed; it had put him in danger but it also brought out the best in him—the bravery, the sense of daring.

Later, George Bernard Shaw remembered meeting him during his years as a fighter pilot. Shaw wrote: "When I met Robert at the flying station on the west front, in abominably cold weather, with a frostbite on his face hardly healed, he told me that the six months he had been there had been the happiest of his life. An amazing thing to say considering his exceptionally fortunate and happy circumstances at home, but he evidently meant it. To a man with his power of standing up to danger—which must mean enjoying it—war must have intensified his life as nothing else could; he got a grip of it that he could not through art or love. I suppose that is what makes the soldier."

When news came in January 1918 that his plane had crashed in Italy, Lady Gregory was at Coole. She had to go to Galway on the train and tell Margaret. "I stood there," she wrote in her diary, "and Margaret came in. 'Is he dead?'... Then I sat down on the floor and cried." The RAF casualty card reads that Robert was "last seen at 2,000 feet near Monastiero. Went into spin and crashed to ground with engine full on. Investigation fails to discover cause of accident." But Lady Gregory and her daughter-in-law believed that he had been shot down mistakenly by an Italian pilot.

In early February Lady Gregory wrote to W.B. Yeats: "If you feel like it some time—write something down that we may keep—you understood him better than many." Later, she wrote, suggesting that he "would send

a paragraph—just something of what I know you are feeling—to the *Observer*—or failing that the *Nation*". Yeats's obituary of Robert Gregory appeared in the *Observer* on 17 February. It began: "I have known no man accomplished in so many ways as Major Robert Gregory, who was killed in action a couple of weeks ago and buried by his fellow-airmen in the beautiful cemetery at Padua. His very accomplishment hid from many his genius. He had so many sides: painter, classical scholar, scholar in painting and in modern literature, boxer, horseman, airman—he had the Military Cross and the Legion d'Honneur—that some among his friends were not sure what his work would be."

Yeats had spent the war years moving between Ireland and England, and living as though the war had nothing to do with him. In June 1915 he wrote to John Quinn: "It is merely the most expensive outbreak of insolence and stupidity the world has ever seen, and I give it as little of my thought as I can. I went to my club this afternoon to look at the war news, but read Keats's *Lamia* instead." When asked for a contribution for an anthology to raise funds for those affected by the war, he offered a short poem which began:

> I think it better that in times like these
> A poet's mouth be silent, for in truth
> We have no gift to set a statesman right.

Later, when he came to edit the *Oxford Book of Modern Verse*, he would exclude the poets of the First World War on the basis that "passive suffering is not a theme for poetry". Despite his efforts to ignore the war as it went on, he was deeply opposed to the introduction of conscription in Ireland. When it was threatened, he told a friend: "If the government go on with conscription there may be some disastrous outbreak—I doubt the priests & the leaders being able to keep the wild bloods to passive resistance. I have seen a good many people here in the west [of Ireland] & cannot imagine a more dangerous condition of things, the old historical passion is at its greatest intensity."

The war did not really interest Yeats, however, until it became personal, until his best friend's only child was shot down, but even then his response was slow, uneven, strange. He wrote four poems about Robert Gregory, two of which are oddly unconsidered and raw, one of which remains one of the greatest elegies in English poetry and the other one a touching, tender and exquisite lyric about the dilemma of those in Ireland whose loyalties were stretched, ambiguous and hard to define during the First World War.

'Shepherd and Goatherd', the first poem, is awkwardly and uneasily made, and seemed to emphasize Robert Gregory's lack of any real achievement. The dead man, Yeats wrote,

…left the house as in his father's time
As though he knew himself, as it were, a cuckoo,
No settled man. And now that he is gone
There's nothing of him left but half a score
Of sorrowful, austere, sweet, lofty pipe tunes.

In 1920, as what was later known as the War of Independence raged in Ireland, with British troops often out of control, Yeats, who was in Oxford, saw the activities of the British Army as a betrayal of what Robert Gregory, whom he referred to as one of "the cheated dead", had died for:

Yet rise from your Italian tomb,
Flit to Kiltartan Cross and stay
Till certain second thoughts have come
Upon the cause you served, that we
Imagined such a fine affair:
Half-drunk or whole-mad soldiery
Are murdering your tenants there.

In a note on an envelope, Lady Gregory wrote: "I did not like this and asked not to have it published…" And in her journal: "I cannot bear the dragging of R. from his grave to make what I think a not very sincere poem… I hardly know why it gives me extraordinary pain and it seems too late to stop it… and I fear the night."

Yeats's poem 'In Memory of Major Robert Gregory'

was begun on a visit to Coole in April 1918 and finished in May. Yeats wrote to his wife as he composed the poem: "It is pathetic for Lady Gregory constantly says that it is his monument—all that remains." Despite Yeats's view on the First World War, his poem is one of the greatest poems about the war, and about the loss of a young soldier in any war. Its pathos is particular, but its tone is magisterial. In between the two is the idea that anyone could read the poem and find truth and comfort in the detailed and shivering sense of grief evoked for a young life cut down, a grief whose contours are constantly postponed and held back in the poem, thus suggesting something almost unmentionable, almost unbearable, as the "thought / Of that late death took all my heart for speech".

'An Irish Airman Foresees His Death' was written by Yeats in June or July of 1918. Just as his elegy, which was written to console, saw no reason to limit itself in its praise of Robert Gregory, now Yeats saw no reason to confine himself to the fact that Robert Gregory had supported the imperial cause. He wrote for the living not the dead, and he was concerned and animated by the haunting conflict in Lady Gregory's own mind that her son had died for a country which was not Ireland. In giving a voice to the dead man, he also gave him an urge for some large and healing self-discovery in his time as an airman, and a view that he cared for neither Ireland nor England, but for Kiltartan, the place near Coole, the place which his mother had

made matter. Yeats filled his poem with a refusal of any easy choice between the two countries. He made the war personal rather than political. He made the rhymes simple, natural. He made the voice eloquent, wise, accepting; he allowed it to whisper, as though to comfort those who feared the night in the aftermath of loss. He made a war death close to an adventure, a sad but inevitable completion:

> I know that I shall meet my fate
> Somewhere among the clouds above;
> Those that I fight I do not hate,
> Those that I guard I do not love;
> My country is Kiltartan Cross,
> My countrymen Kiltartan's poor,
> No likely end could bring them loss
> Or leave them happier than before.
> Nor law, nor duty bade me fight,
> Nor public men, nor cheering crowds,
> A lonely impulse of delight
> Drove to this tumult in the clouds;
> I balanced all, brought all to mind,
> The years to come seemed waste of breath,
> A waste of breath the years behind
> In balance with this life, this death.

WRITING
ON THE WALL

Jeanette Winterson

JEANETTE WINTERSON was born in Manchester in 1960. Her first novel, *Oranges Are Not the Only Fruit*, was published when she was 24 years old. It won the 1985 Whitbread Award for a First Novel, and its 1990 adaptation by Winterson for television won the BAFTA Award for Best Drama.

May 18th. Sunday. John Fisher overtook me on the other side of Rydale. He talked much about the alteration in the times and observed that in a short time there would only be two ranks of people: the very rich and the very poor. "For those who have small estates are forced to sell and all the land goes into one hand."

––––––––––

This morning we heard a boat torpedoed in the bay. I think only 10 lives were saved. I wish the Boche would have the pluck to come right in and make a clean sweep of the pleasure boats and the promenaders on the Spa, and all the stinking Leeds and Bradford war-profiteers now reading *John Bull* on Scarborough Sands.

––––––––––

The danger lies in forgetting.

––––––––––

And should the world itself forget your name
Say this to the still earth: *I flow*
Say this to the quick stream: *I am.*

I LEFT THESE FOUR PASSAGES unnamed and undated so that you would read them without reference to anything else. Just for a moment the thing in itself as it really is—before history intervenes.

It's not that I don't believe in context—I do. It's not that I believe we are enriched by ignorance—we aren't. But life comes so ready-chopped into bite-size chunks that it can be hard to hear the fresh-peeled voice.

And I wanted you to find these things as I found them, randomly reading by the fire—my habit to pull a pile of books from my shelves like maps for a journey to be made on foot.

Dorothy Wordsworth walked all the time—often with her brother William, or their friend Coleridge, and often alone. Her journal is full of what they saw on their rambles around the Lake District—animals and birds, wild flowers, the changing weather, the flow of beauty.

And poverty.

The first passage you read is from her journal written in 1800. The Industrial Revolution was changing everything:

the weaver, the spinner, the dyer, the smallholder all finding it hard to make an ordinary living. Dorothy notes how many new beggars she meets—men and woman cut off from their meagre but adequate way of life. Factories had begun to replace cottage industry. Food production for the fierce, frightening towns was causing scarcity in the countryside and in the villages. Dorothy's friend John Fisher was not an economist or a politician—but he might have been prophesying the present state of the world. The poor are getting poorer. The middle classes are struggling. There is a growing underclass of the unemployed. The rich are getting richer.

The world's eighty-five richest people control more wealth than the poorest 3.5 billion (source Oxfam).

Dorothy Wordsworth was still alive in 1848 when Karl Marx published *The Communist Manifesto* at the same time as a wave of revolutions broke across Europe and into South America. The revolutions didn't hold. The workers were disorganized and there was little international co-operation. But the growing labour movement was real, although it took until the end of the century for trade unions to become generally accepted and generally legal, whether in Europe or the United States.

Marx's view was straightforward: Socialism was needed to provide for man's animal needs (food and water, shelter,

safety, health, rest, a clean environment), so that man might have leisure to supply his human needs.

What are our human needs? Love and friendship, family life, education, intellectual pursuit, sport, enquiry, curiosity, books, music, art in all its changing shapes and forms. We will all have things we want to add here, but the common denominator is creativity.

A meal cooked from scratch with fresh ingredients is a creative act. Planting a garden is a creative act. Your conversation with a friend that unlocks new ideas. The swing you build out of rope and an old tyre for the kids. The way you make your own style.

Creativity isn't only about icons that stand the test of time.

Creativity is every day in everything we do.

Or it should be. Or it could be.

Think about it.

Every child is born creative. Before they can speak, children know how to dance to a rhythm and how to clap to a beat. Children love to hear music. Soon they love to sing. Before they learn to read, children delight in being told a story. They make up their own stories. They act in their own plays. Children paint and draw. Children build kingdoms out of saucepans. Children are inventive and playful. It takes differing amounts of time and effort, or time and neglect, to knock this natural creativity out of them and produce adults who really believe that they are both uncreative and uninterested in anything that is creative.

Utilitarian education, combined with saturation levels of low-grade mass culture, turns creativity into the gift and preserve of a few. I don't believe that everyone can be or wants to be a writer, painter, musician, actor, etc., but I do believe that we are all on the *creative continuum*—and that, in different strengths and doses, we need to keep creativity in our lives.

There's a popular myth peddled as a fact that art isn't democratic. Classical music is too difficult. Literature is rarefied. Theatre and opera are for people with leisure and money. Contemporary art is a joke. Old Masters are about the price tag. Why would kids want to go to the National Gallery when they can go to a bowling alley? The rows about funding the arts depend on this myth of elitism.

But it is a new myth—and it's a money myth, and it's a mass-culture myth, and it suits the true elite of the world who has no interest in democracy or in human potential. The elite of the world depends on cheap labour, mental lethargy, depression so deep that change seems impossible, and strict segregation of entitlement. If you are born poor the chances of doing anything worthwhile with your life are slim and getting slimmer. If you are middle-class you will be doing your best to cling onto what you have, fearful that your children will have to work harder and longer and for less. Fear is the best weapon of control.

As the money gets squeezed, arts funding gets cut. Politicians talk about tough choices, though these never

include nuclear weapons or vast subsidies to the private companies who run public transport or who are in charge of prisons. We can always find the money to bail out banks that continue to pay huge bonuses funded by the taxpayer. We can always afford a war.

The easy reasoning behind cutting funding to the arts and access to the arts is the same reasoning that refuses children musical training at school and closes libraries: non-essential. Lovely when we can afford it. Regretfully must go when we can't.

But poetry and music, painting, dance, drama, storytelling are not bolt-ons of modern life; they are our earliest expressions of what it means to be a human being.

When we were hunting mammoths. When we were scraping a living from the back-breaking clay, prey to shortages and the weather, we were painting our cave walls with the animals we saw. We were singing. We were acting out the life of our ancestors in dance, gesture, drama. Ritual to placate nature and angry gods developed into the earliest versions of theatre.

Poetry happened as a way of passing down orally, by memory, important things about a clan, a tribe, a family, a victory, a defeat, a loss, a migration. Record-keeping began as an art form and not an act of administration.

In a sense, art happens before history—there can be no history if there is no record. But the record developed as an art form; think the tombs of Egypt, Aztec temples,

Greek statues. None of this is ornament; it is a way of making the most ephemeral of things—life—into a solid. The spirit behind art is to pass on what we are, who we were, across time, and through generations. What we are cannot be understood if it can only disappear.

But art is more than a recording angel—it is also the inventive, imaginative, inspirational part of us. Look at the temple at Angkor Wat. Look at the cathedral at Chartres. Look at everything we made without a machine tool in sight. Look at our absurd, unprofitable delight in making a thing as beautiful and expressive as it could be, when the labour was vast and difficult, when a man knew he would not live to see his work completed, and that his son or other men would take over.

Think back to a time when there is no running water, no indoor heating, where food must be grown locally, or you starve, where there are no labour-saving devices, where it will take you all day to travel to the next town, where operations happen without anaesthetic, where the mortality rate is forty per cent and where, even so, someone sits down to write a poem, to spend months making a harpsichord or a flute or a violin, where we gather in an unheated room to listen to music. Where the men and women in the fields sing as they work. Where a travelling show on a wagon was something people who were labouring from dawn till dusk wanted to see...

If art is a luxury, then being human is a luxury.

Is being human becoming a luxury that fewer and fewer people can afford?

We hear a lot about the work ethic, as though toil, however ceaseless or senseless, will always make things better—like poor Boxer the draught horse in *Animal Farm*, whose answer to every problem is "I will work harder".

But ceaseless toil was one of the ills that flew out of Pandora's Box and part of the punishment handed out by Yahweh to Adam and Eve as he expelled them from Eden.

What is the point of human labour if it makes nothing better for the one who is labouring?

And if we must toil, can we not expect human labour to work towards a common good?

In 2008, when the global crisis happened, it seemed like a golden opportunity, even by the standards of the Midas markets, to ask questions about money. Would Capitalism examine its ideology: that wealth creation for a few will benefit the many? Or that the Free Market promotes healthy competition and natural cost control?

Would Capitalism examine its rhetoric, compressed into that famous acronym TINA—There Is No Alternative?

Would Capitalism examine its values? By which I mean the suicide attempt to turn all of the planet and all of its peoples into one vast money-making machine.

The answer is no. The party line, from all shades of politics, was that the crisis had nothing to do with what is inherently wrong with Capitalism. Politicians talked about it like a

powerful car, stolen for a while by a few crazy teenagers and driven too fast and crashed. Fix the car, get the decent drivers back behind the wheel, and off we go towards the sunshine.

In 2014 Thomas Piketty's surprise best-seller *Capital* gives me hope that the debate is finally beginning. Using Marx's original title, and questioning the whole basis of neo-liberal economics, whether the Chicago School of Milton Friedman or the Austrian style of Hayek, so beloved of Margaret Thatcher and George Bush, Capital mark 2 like Capital mark 1, is a clear alternative to There Is No Alternative. At Manchester, the university where I teach, our students have challenged faculty to stop peddling neo-liberal economics as if they are a law of nature.

The Cambridge economist Ha Joon Chang has published a new textbook introduction, *Economics: The User's Guide*, that defies the rigid orthodoxies of box-set economics, outlining instead different understandings of what money is and how it operates in a complex global market.

Why does this matter?

What is the relationship between economics and creativity?

This morning we heard a boat torpedoed in the bay. I think only 10 lives were saved. I wish the Boche would have the pluck to come right in and make a clean sweep of the pleasure boats and the promenaders on the Spa, and all the stinking Leeds and Bradford war-profiteers now reading John Bull on Scarborough Sands.

Wilfred Owen wrote that to his mother from his convalescence at Scarborough. He was about to go back to the Front, where he was killed in the last week of the war. Human losses were in the millions. Britain's economy was ruined. The national debt before the war was around £750 million. After the war it had risen to more than £6 *billion*. The armaments industry made unimaginable fortunes.

The war effort, with every available man, woman and child drafted into service of one kind or another, under the banner "Your Country Needs You", took no account of what was lost. The sacrifice was human life but it was also human potential—because human potential costs money.

Here's Owen's poem, 'Futility'.

Move him into the sun—
Gently its touch awoke him once
At home, whispering of fields unsown.
Always it woke him, even in France,
Until this morning, and this snow.
If anything might rouse him now
The kind old sun will know.

Think how it wakes the seeds—
Woke, once, the clays of a cold star.
Are limbs, so dear-achieved, are sides,
Full-nerved—still warm—too hard to stir?
Was it for this the clay grew tall?

—O what made fatuous sunbeams toil
To break earth's sleep at all?

At the end of the First World War our motto became "Lest We Forget". Poppy Days continue to commemorate the dead—but what about the living?

The way we live is not a law like gravity; it is propositional. We can change the story because we are the story.

In 2013 the then UK Culture Secretary Maria Miller (before she had to resign over her excessive personal expenses out of taypayers' money) said, "our focus must be on culture's economic impact". Why did nobody ask her why we are not discussing the economy's impact on culture and creativity?

Is the economy for human beings or are human beings for the economy?

I do not believe that the point of being human is for the majority to scrape a living with not a chance at the imaginative, open, ingenious, curious, playful, creative life that we see in every one of our children.

How can we dream if we can't sleep in safety? What chance to read a book, let alone write one, without a home? How can you buy the cheapest theatre ticket when you need two jobs just to feed the kids? How will you take your kids to a free museum if nobody took you?

Times are not tough because "hard-working" people didn't work hard enough. Times are not tough because there are too many immigrants or not enough resources.

Of course business can afford to pay a living wage—it shouldn't even be a question. Of course we can afford education and school meals. It's cheaper than crime. It's cheaper than prison.

I know that paid work can't always be satisfying or meaningful—all the more reason why those who do such necessary jobs should expect a living wage and a controlled working week. Technology has de-skilled our workforce without delivering benefit in terms of fewer hours to work. A four-day week is laughed at as a fantasy, but why is it a fantasy? If we have to mind the machine, at least let's have enough time off to find out what it means not to be a machine.

I have been told by rich people that art is a luxury (though not for them). I have been told by poor political activists that art is a luxury—get the food and housing and health sorted first—those basic needs that Capitalism continually promises and yet fails to supply. We do need to address those basic needs—the acute malaise of food for the hungry, homes for the homeless, medicine for the sick. But underneath the endless, acute crises of our planet is the chronic crisis of how we manage what it is to be human.

The danger lies in forgetting what we had. (Adrienne Rich)

And I am thinking about the first public library in Britain—opened in Manchester in 1852—opposed by the Conservative Government on two grounds:

1) Cost.

2) The radical social transformation it might encourage.

By 1900 there were 294 libraries across the United Kingdom, most paid for by the self-made millionaire and philanthropist Andrew Carnegie. In his book *The Gospel of Wealth*, he wrote: "Man does not live by bread alone… there is no class so pitiably wretched as that which possesses money and nothing else."

He was wrong about that—what about no money and nothing else?

And I am thinking about the great economist John Maynard Keynes—founder of the World Bank and the IMF—persuading the British government to accept paintings from the Degas collection, much of it modern art (modern art!) including Cézanne and Matisse, from the French in lieu of payment for war debt after the First World War, so that the pictures could be displayed in the National Gallery for everyone to see.

And as the Arts Council of England braces itself for cut after cut, because art is a luxury, let's not forget it was Keynes who set it up.

Keynes was no Marxist, but like Marx he believed that wealth should be in service to human beings. He didn't believe in the worship of wealth at whatever the human cost.

And I am thinking about the building of the Royal Festival Hall after the Second World War, a Socialist project,

because in those days Socialism still remembered that creativity is the democratic inheritance of us all.

And I am thinking of the outrage of the local community in Gateshead in 2014 when Morrison's supermarket projected an image of a baguette across the wings of Antony Gormley's *Angel of the North*—fabricated by unemployed steel workers.

Yes we buy and sell, and we buy and sell works of art, and we expect to pay for books and films and for tickets to shows, but there is something sickening in a supermarket advertising its cheap carbohydrate on an icon of hope that towers over the landscape reminding us that there is such a thing as the soul—and who can set a price on that?

What does it profit a man if he gains the whole world and loses his own soul?

You don't have to be religious to know exactly what that means. You don't have to believe in the afterlife to know what it is to have soul or to know what is meant by soulless and soul-destroying.

We know we are destroying our planet. We know that countless millions of people live in poverty, dirt and despair. In India and China fifteen-hour days in suffocating factories are still common. In the West a fifteen-hour day is normal for the growing number of people who need two jobs to make ends meet.

The World Health Organization estimates that depression will soon be the biggest killer after heart disease.

Children are not born depressed. We talk about days lost to depression but only in terms of productivity. Why do we not talk about lives lost to depression?

And how might a creative world designed by humans for humans change that?

When James Hargreaves, an illiterate weaver from Lancashire, invented the Spinning Jenny (1764), which could do the work of eight men, the technology that started the industrial revolution should have been liberating not threatening. In fact it became the measure of what was lost: autonomy, independence, livelihood, as skilled workers became factory hands. But that was not the necessary or the logical outcome. Faster and better should be a benefit not a terror. Why is profit more important than people?

And I'm back in Manchester where I was born, reading Friedrich Engels as he looks at the wastelands of factories and slagheaps. The drunken men. The worn-out women. The pale, unhappy children. This is "what happens when men regard each other only as useful objects" (*The Condition of the Working Class in England in 1844*).

The creative continuum recognizes that human beings are much more than useful objects.

From the child's drawing stuck on the fridge to the Jasper Johns in the gallery. From Mozart at the opera house to the woman singing as she cleans the windows. The kid practising the piano. Glenn Gould playing Bach. This is not ornament or hobby. This is not luxury or extra.

What is a human being? What is being human for?

And should the world itself forget your name
Say this to the still earth: *I flow*
Say this to the quick stream: *I am*

(DON PATERSON, *Orpheus*, 2006)

THE WORLD OF YESTERDAY
STEFAN ZWEIG

'*The World of Yesterday* is one of the greatest memoirs of the twentieth century, as perfect in its evocation of the world Zweig loved, as it is in its portrayal of how that world was destroyed' David Hare

JOURNEY BY MOONLIGHT
ANTAL SZERB

'Just divine... makes you imagine the author has had private access to your own soul' Nicholas Lezard, *Guardian*

BONITA AVENUE
PETER BUWALDA

'One wild ride: a swirling helix of a family saga... a new writer as toe-curling as early Roth, as roomy as Franzen and as caustic as Houellebecq' *Sunday Telegraph*

THE PARROTS
FILIPPO BOLOGNA

'A five-star satire on literary vanity... a wonderful, surprising novel' *Metro*

I WAS JACK MORTIMER
ALEXANDER LERNET-HOLENIA

'Terrific... a truly clever, rather wonderful book that both plays with and defies genre' Eileen Battersby, *Irish Times*

SONG FOR AN APPROACHING STORM
PETER FRÖBERG IDLING

'Beautifully evocative... a must-read novel' *Daily Mail*

THE RABBIT BACK LITERATURE SOCIETY
PASI ILMARI JÄÄSKELÄINEN

'Wonderfully knotty... a very grown-up fantasy masquerading as quirky fable. Unexpected, thrilling and absurd' *Sunday Telegraph*

RED LOVE: THE STORY OF AN EAST GERMAN FAMILY
MAXIM LEO

'Beautiful and supremely touching... an unbearably poignant description of a world that no longer exists' *Sunday Telegraph*

THE BREAK
PIETRO GROSSI

'Small and perfectly formed... reaching its end leaves the reader desirous to start all over again' *Independent*

FROM THE FATHERLAND, WITH LOVE
RYU MURAKAMI

'If Haruki is *The Beatles* of Japanese literature, Ryu is its *Rolling Stones*' David Pilling

BUTTERFLIES IN NOVEMBER
AUÐUR AVA ÓLAFSDÓTTIR

'A funny, moving and occasionally bizarre exploration of life's upheavals and reversals' *Financial Times*

BARCELONA SHADOWS
MARC PASTOR

'As gruesome as it is gripping... the writing is extraordinarily vivid... Highly recommended' *Independent*

THE LAST DAYS
LAURENT SEKSIK

'Mesmerising... Seksik's portrait of Zweig's final months is dignified and tender' *Financial Times*

BY BLOOD
ELLEN ULLMAN

'Delicious and intriguing' *Daily Telegraph*

WHILE THE GODS WERE SLEEPING
ERWIN MORTIER

'A monumental, phenomenal book' *De Morgen*

THE BRETHREN
ROBERT MERLE

'A master of the historical novel' *Guardian*